John F. Kennedy
COMMANDER IN CHIEF

JOHN F. KENNEDY

COMMANDER IN CHIEF

A Profile in Leadership

PIERRE SALINGER

FOREWORD BY ARTHUR M. SCHLESINGER, JR.

PHOTOGRAPHIC RESEARCH BY WILLIAM S. BUTLER

PENGUIN STUDIO

PENGUIN STUDIO

Published by the Penguin Group

Penguin Putnam Inc., 375 Hudson Street, New York, New York 10014, U.S.A.

Penguin Books Ltd, 27 Wrights Lane, London W8 5TZ, England

Penguin Books Australia Ltd, Ringwood, Victoria, Australia

Penguin Books Canada Ltd, 10 Alcorn Avenue, Toronto, Ontario, Canada M4V 3B2

Penguin Books (N.Z.) Ltd, 182-190 Wairau Road, Auckland 10, New Zealand

Penguin Books Ltd, Registered Offices: Harmondsworth, Middlesex, England

First published in 1997 by Penguin Studio, a member of Penguin Putnam Inc.

1 3 5 7 9 10 8 6 4 2

Copyright © Gateway America LLC, 1997
Foreword copyright © Arthur M. Schlesinger, Jr., 1997
All rights reserved

This book was conceived and researched by L. Douglas Keeney and William S. Butler,
who wish to thank James B. Hill of the John Fitzgerald Kennedy Library for his invaluable contributions to the project.

CIP data available

ISBN 0-670-86310-6

Printed in the United States of America
Set in Centaur
DESIGNED BY BRIAN MULLIGAN

CONTENTS

John F. Kennedy was one of the most photographed presidents in history, and one of the most photogenic too, but this book presents him in a relatively unfamiliar context. Our armed services are always tireless in taking pictures of high officials visiting military installations, and William Butler recently discovered in Defense Department files these previously unavailable photographs of President Kennedy in martial settings. Pierre Salinger, who was not only the president's very able press secretary but also his personal friend, provides a well-informed and evocative text.

Kennedy was a man of peace, but he was also a Second World War hero who became president at the height of the Cold War in a time of what he described as "maximum danger." The international problems he faced had military dimensions, and military strength was one of the means by which he hoped to deter Soviet expansion and a Third World War. He therefore took very seriously his responsibilities as commander in chief and had an acute interest in the posture and strategy of defense.

In order to avoid undue reliance on nuclear weapons, for example, he called for the diversification of American forces to make possible a "graduated response" to military challenges. While it was unquestionably essential to find alternatives to the bomb, some of his early enthusiasms, as for counter-guerrilla units and the Green Berets, did not prove effective or fruitful.

A navy veteran, Kennedy took great pride in the American armed forces. It must be added that he much preferred the lower ranks to the top brass. Military pomp and circumstance bored and irritated him. "John Kennedy," wrote Jerry Bruno, who, as a favorite advance man, had to deal with these matters, "hated military pageants—with a passion." He equally resented the Pentagon's tutorial sessions. He was not one for men in uniforms with pointers reading aloud off flip charts sentences he could read much faster for himself. In the spring of 1961, Kennedy was given the Net Evaluation, an annual doomsday briefing analyzing

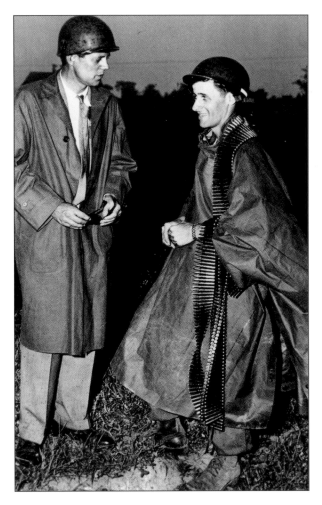

Senator Kennedy visits one of his Massachusetts constituents, Sgt. Ezra Emery, on a rainy day at Camp Drum, New York, in August 1952.

the chances of nuclear war. An air force general presented it, said Roswell Gilpatrick, the Deputy Secretary of Defense, "as though it were for a kindergarten class. . . . Finally Kennedy got up and walked right out in the middle of it, and that was the end of it. And we never had another one."

As this book suggests, the commander in chief grew increasingly disillusioned with the quality of advice he received from the Joint Chiefs of Staff. In the 1960 campaign, Kennedy had accepted the Pentagon's theory of a missile gap, and the disproof of the gap by satellite surveillance raised questions in his mind about military assessments. The subsequent endorsement of the Bay of Pigs project by the Joint Chiefs increased his skepticism. "If it hadn't been for Cuba," Kennedy told me in May 1961, "we might be about to intervene in Laos." Waving a sheaf of cables that General Lemnitzer, the Chairman of the Joint Chiefs, had sent from Laos, he added, "I might have taken this advice seriously."

Of the Joint Chiefs he inherited from President Eisenhower, he liked best General David Shoup, the commandant of the Marine Corps, who believed that the job of the marines was "to teaching fighting, but not hate." He liked least General Curtis LeMay of the Air Force. Every time the president had to see LeMay, Gilpatrick recalled, "he ended up in a sort of fit. I mean he would just be frantic at the end of a session with LeMay because, you know, LeMay couldn't listen or wouldn't take in, and he would make what Kennedy considered . . . outrageous proposals that bore no relation to the state of affairs in the 1960s." But LeMay's popularity in the ranks and with Congress gave him immunity. "We would have had a major revolt on our hands," said Gilpatrick, "if we hadn't promoted LeMay."

Kennedy counted on Secretary of Defense Robert McNamara to control the military, and, with Gilpatrick and others, McNamara did an excellent job of containment. After a time, Kennedy brought in General Maxwell Taylor to serve as White House liaison between the Joint Chiefs and later as the JCS chairman. But the quality of advice did not notably improve. During the Cuban missile crisis, the Chiefs urged a surprise strike against the bases. We now know that the Soviet forces in Cuba had tactical missiles equipped with nuclear warheads. If the president had followed the Chiefs' recommendations, the result might well have been nuclear war.

When Kennedy's brilliant management got the missiles out peacefully, some of the Chiefs were irate. "We have been had," said Admiral George Anderson. General LeMay said, "Why don't we go in and make a strike on Monday anyway." "The military are mad," the president told me the morning after the resolution of the crisis. "They wanted to do this. It's lucky for us that we have McNamara over there." "The first advice I'm going to give my

successor," he told Ben Bradlee, "is to watch the generals and to avoid feeling that just because they were military men their opinions on military matters were worth a damn."

Charles W. Bailey and Fletcher Knebel published in 1962 a popular thriller, *Seven Days in May*, depicting a Pentagon attempt to depose a president the military considered too soft in foreign policy. Kennedy said, "It's possible. It could happen in this country, but the conditions would have to be just right. If, for example, the country had a young president, and he had a Bay of Pigs, there would be a certain uneasiness." If there were a second Bay of Pigs, the military would feel it their obligation to save the republic. "Then, if there were a third Bay of Pigs, it could happen. . . . But it won't happen on my watch."

Still, he took no chances and, to the dismay of the Pentagon, encouraged John Frankenheimer to turn *Seven Days in May* into a movie. In 1963, after the American University speech, he pursued, over strong military objections, his goal of a Nuclear Test Ban Treaty. "Let us never negotiate out of fear," he had said in his inaugural address. "But let us never fear to negotiate." Much to his relief, the Senate and the country received the Nuclear Test Ban Treaty with enthusiasm.

For all his distrust of the top brass, Kennedy, as an ex-fighting man himself, had the warmest feelings of admiration and regard for American soldiers and sailors. The photographs herein testify to the high value he placed on the brave men and women who so faithfully serve the American people as guardians of the republic.

—*Arthur M. Schlesinger, Jr.*

★ ★ ★ PROLOGUE

For all American presidents of modern vintage, virtually their entire life in office was photographed, filmed, and recorded. It will surely surprise no one to know that a majority percentage of the public and private utterances of John F. Kennedy were committed to tape and are now stored for posterity in the Kennedy Library in Boston. Similarly, the photographic and documentary film record of the Kennedy administration is exhaustive and is held at the Kennedy Library and other national archives. For researchers and historians, this huge inventory of images is a treasure trove of captured moments. Through innumerable books and magazine articles we have seen Jack Kennedy in the White House, at Hyannis Port, in Palm Beach, on his European trips, sailing on the *Honey Fitz*, playing golf, at the Capitol. Overlooked, so far, is a collection of photographs contained in the files of the Department of Defense (most of which are also held at the Kennedy Library and the National Archives). The collection consists of photographs of President Kennedy as he visited military bases and attended firepower demonstrations in the course of his duties as commander in chief of U.S. armed forces. It was customary for armed services photographers to document such visits in their entirety, from the moment the commander in chief stepped off the plane to his last wave good-bye. To the general public in the 1960s, these photographs had little news value; in fact, most of them were never offered to civilian news bureaus. They may have been used on armed forces television, or in base newspapers, but most were just filed and stored away.

From the perspective of the 1990s, however, this body of photography is a found treasure. An examination of the pictures is revealing, because it leads us to a new understanding of Kennedy: He was an active and involved commander in chief. In fact, the photographs support the contention that John Kennedy's role as commander in chief defined his administration as much as any other area of his presidency.

Also included here is a unique point of view: Over the course of a series of interviews for a television documentary, Marcus Wolf, former head of the now infamous East German spy organization STASI, revealed how the Communists perceived Kennedy in his role as commander in chief. These statements are presented as sidebar material throughout *JFK: Com-*

mander in Chief. Most interesting is the eastern bloc's slow recognition, developed over time, that Kennedy's capabilities as an adversary were formidable.

Kennedy's relationship with the armed forces, forged by his own years of service in World War II and the turbulent world circumstances of the early 1960s, was complex. Nearly every memorable international event, crisis, or action of his administration had a crucial military component that Kennedy himself personally oversaw. And the troubled world of the 1960s was quite different from the world his predecessor, General Dwight Eisenhower, faced in the late 1940s and 1950s. It was so different that the new president immediately set about dismantling and reshaping the massed-force doctrines and practices of the D-Day commander's army, much to the irritation and outright contempt of the military old guard, which considered Kennedy a weak and naive usurper of traditional U.S. military power.

Kennedy faced no huge targets like Normandy Beach on his military map, only dozens of small guerrilla fights in Latin America, Africa, and Southeast Asia. He saw the hand of his ideological nemesis, Nikita Khrushchev, behind local insurgencies and in the provocations attending the crisis in Berlin. But he understood that the Soviet Union was an enemy that could not be attacked head-on without committing nuclear suicide. Rather, he realized the necessity of reforming the U.S. military so that it could respond quickly and lethally to the "hot spots" Khrushchev fomented, and, through military restraint, of keeping all international conflicts below the nuclear threshold.

In this military environment, vigilance was paramount. When a "domino" was in danger of falling—in Laos, Vietnam, Berlin—the United States had to be ready to deploy its arsenal. Being ready to go, being equipped properly, being superbly conditioned (the elite navy SEALS were a Kennedy favorite) was a Kennedy doctrine. So was a huge military budget. Increases in military spending on all services occurred in the Kennedy years, which gave the defense establishment a lot of men and a lot of weapons to utilize, and which, ironically, made both difficult to control. But Kennedy was determined to be an active commander in chief, especially after the mistakes of the Bay of Pigs operation. On many occasions he reviewed his "new" army, navy, and air force, spending the time to see exactly what the ground-level soldier was wearing, carrying, and thinking. The photographs that follow are the proof of his interest.

The military side of the Kennedy presidency offers a window through which to observe the man. It is a unique angle, remarkable for what it offers: a jaunty, relaxed Kennedy, enjoying his field trips and his encounters with the troops despite the gravity and tension he must have felt in the chill of the cold war. And we must remember: In three years, challenged by a belligerent enemy in Cuba, in Vietnam, and in Berlin, Kennedy the commander in chief managed to keep the United States out of global war, and never committed U.S. troops to live-fire combat.

—*William S. Butler*

John F. Kennedy
Commander in Chief

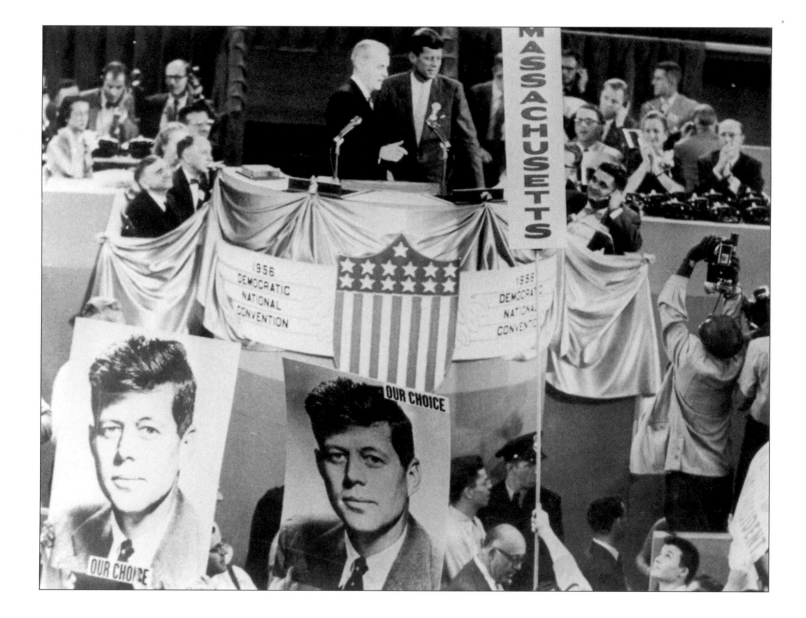

★ THE KENNEDYS
★ AND ME

The young senator from Massachusetts, John F. Kennedy, was vying for the vice presidential nomination of the Democratic Party at the 1956 convention in Chicago. He had considerable support but lost the nomination to Estes Kefauver. Despite this loss, Senator Kennedy made a deep impression on many Democrats, and talent-spotters, including Pierre Salinger, felt that he would become a player in the next presidential election.

THE 1956 DEMOCRATIC NATIONAL CONVENTION

My first exposure to John F. Kennedy was in 1956, at the Democratic National Convention. I was working for *Collier's* magazine. One of my colleagues was Teddy White; the magazine decided that we should go to Chicago and cover the convention. At the convention, Adlai Stevenson was nominated for president a second time. I had worked for him in California in 1952, at the time of his first nomination.

After Stevenson's nomination, the convention turned to the vice presidential nomination, and Stevenson, in a rare move, said, in effect, "I'm not making the vice presidential choice. It's up to the delegates to decide." There were two important candidates for the vice presidency, and one of them was John Kennedy. The other was Estes Kefauver. The first round of voting took place, and Kennedy won. But suddenly people started raising their hands, saying, "We're pulling out of the Kennedy votes. We want to vote for Kefauver." Kefauver ended up getting the nomination. About two hours later, Kennedy gave a speech to the convention that absolutely stunned me. It was a policy speech, looking at the future of America, explaining how we had to make changes in our country. He was totally right. I believed every word he said, and I was moved by the way he spoke. There were no others who were speaking that way at that time. I said to myself, "It's a good thing he didn't become vice president, because he would have lost the election. Stevenson's not going to win. But in 1960 Kennedy's going to be the president of the United States."

Right after the convention, I was contacted by *Collier's* about taking over the magazine's investigation of the Teamsters Union. I agreed to do it because I had a long background in investigative journalism. From the time of the convention until October 1956 I pursued the investigation. I was in Seattle looking into the activities of Dave Beck, I was in Detroit looking into Jimmy Hoffa, and there were many others. Finally, after my office moved from San Francisco to New York, I sat down and started writing the newspaper pieces.

The McClellan Hearings

It was in October that I saw an article in the New York *Herald Tribune* saying there were going to be hearings before the U.S. Senate Select Committee on Improper Activities in the Labor or Management Field—in particular looking at the Teamsters—and that the chief lawyer of the committee was going to be Bobby Kennedy. I went to see my editors and said, "I think I've developed more information than they have yet. I'd like to find out when they're going to have their first hearings. I think that would be a good date for us to start publishing these articles." So I called Bobby Kennedy one morning and said that I'd like to get together with him. I explained what I was doing. He said, "How about getting on a plane right now? Come down and have lunch with me."

I flew down. It was an interesting lunch because I was going to interrogate him on a lot of events, but he wound up interrogating me like mad. We were together for about two and a half hours, and we got along very well. Afterward, I went back to New York.

Not long after that I got a call from one of the editors at *Collier's*. I had just started working

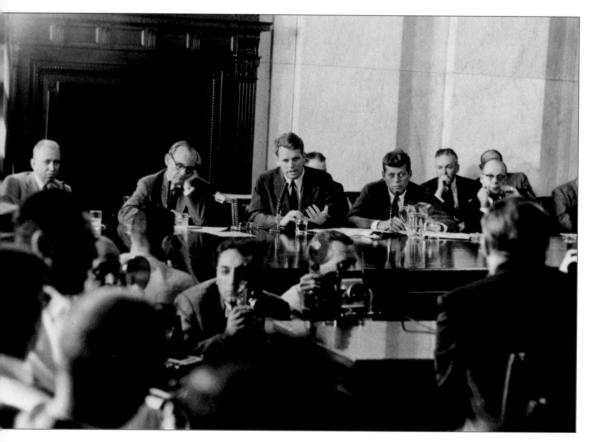

McClellan Committee Chief Counsel Robert Kennedy questions a witness while his brother waits his turn. Because of their similar looks and accents, the Kennedy brothers were sometimes confused with each other. While Kennedy's participation in these hearings was helpful to his relations with the Democratic Party and the labor movement in general, his interest was divided by the details of his reelection campaign in 1958, the springboard to his presidential run in 1960.

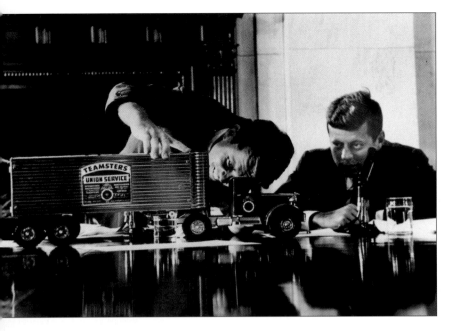

The Kennedy brothers introduce a visual aid to the McClellan hearings.

One of Bobby Kennedy's investigators, Pierre Salinger, passes on some information to Senator Kennedy during the Senate "Racket" hearings. Salinger, who became Senator Kennedy's press liaison during the 1960 presidential campaign and was later press secretary for President Kennedy, had not met his future boss before these hearings.

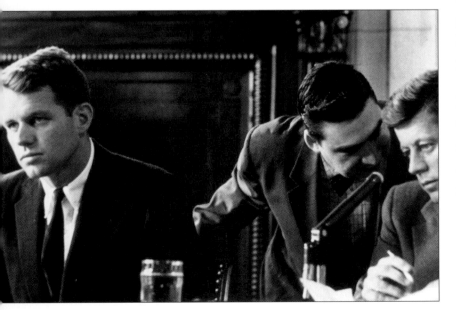

on another piece, involving the Soviet invasion of Hungary. He said, "You don't have to write the story." I said, "Why not?" He said, "We're going out of business." About two weeks later, in December, it was announced that the magazine was going out of business. That morning I got two phone calls. One was from Einar Mohn of the Teamsters Union. He said, "Pierre, I hear you lost your job. How would you like to become the public relations director of the Teamsters Union?" After the shock wore off, I said, "Well, it's a subject I can't make a decision on right now. I'll get back to you." An hour later, Bobby Kennedy called me. He said, "What are you going to do with all those papers you've got, and all that information?" He sent a team up to see me, including a man named Carmine Bellino, who was one of the top investigators for the select committee, and they spent the whole day with me. They walked away excited with the information I had put together.

Soon Bobby called me and said, "Why don't you come and join our committee? You can be an investigator." I quickly agreed. I started work on Valentine's Day, 1957. I flew down to Washington the night before. The next morning I went to the office to see Bobby, who said, "Pierre, I've got a tough day. I don't have time to meet with you, but here are some subpoenas I want you to serve on the Teamsters Union." They were for Einar Mohn, the man who had called me and offered me a job. I went to Mr. Mohn's office and he greeted me warmly: "Pierre, good to see you." I handed him the subpoenas. He said, "Well, I see you made a job decision!"

In the months to come I was a witness many times in the select committee hearings. One day I was sitting next to Bobby when he suddenly tapped me on the shoulder and said, "You ought to say hello to the man next to you on the left. That's my brother, John Kennedy." And that's when I met John Kennedy for the first time.

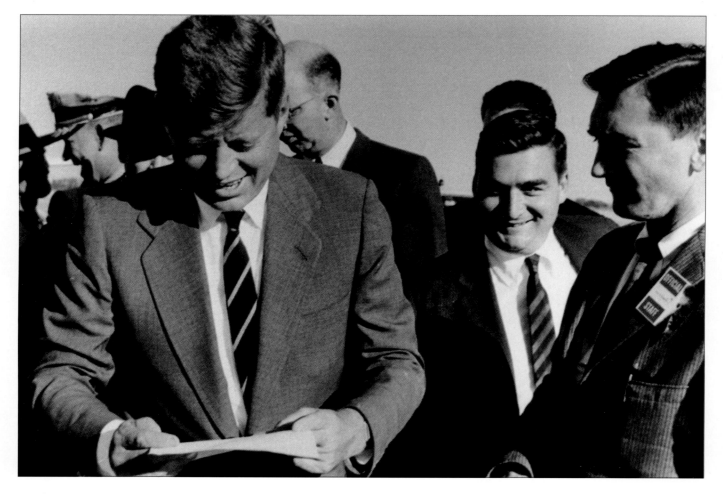

Candidate Kennedy on the campaign trail in October 1960 with Pierre Salinger and Ken O'Donnell (far right), another aide who would become a member of the White House staff.

THE 1960 CAMPAIGN

It was September 1959. I had been with the committee for about two and a half years when I was called by Paul Butler, chairman at that time of the Democratic National Committee. He said he would like me to be the public relations director for the Democratic National Committee for the 1960 elections. I said that I was not sure he wanted me, because I was very biased on this election—I wanted John Kennedy to be elected president. The DNC chairman said, "So do I."

I went to see Bobby and said, "I'm leaving the committee, but I'm taking over as public relations director of the Democratic National Committee." He said, "Don't make that decision for twenty-four hours." The next morning, I got a call from John Kennedy, saying, "Come to my office right away." I did. He said, "Look, Pierre, I'm going to run for president in 1960, and I want you to work for me." With no hesitation at all I said, "You've got me." I didn't even ask him what the job would be. We never talked about salary, we never talked about anything except the fact that I was going to work for him. And then, of course, a couple of days later he told me, "I want you to be the media director for the

campaign." He never suggested I'd be press secretary one day if he got elected. He just wanted me to run the media for the campaign and help get him elected.

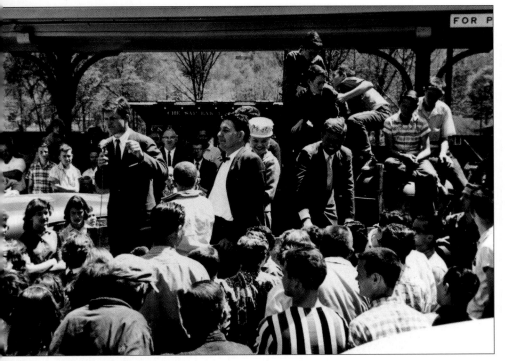

Teddy Kennedy takes the microphone on behalf of his brother at a rally during the West Virginia primary, May 1960. Kennedy's spectacular and unexpected victory in this primary put to rest the idea that a Catholic candidate could not win in a rural southern state.

Kennedy was not yet an official candidate, but he was starting to travel to a number of states. I traveled with him on his private plane, the *Caroline*, and the more I traveled with him, the more I heard him give speeches, and the more I became convinced that he was going to be elected president. I was still thrilled by the way he spoke. I really admired the way he talked to high school and college kids. He would say, "You have to be interested in your future. You have to do the training that's necessary to get a good job, and that job should be something you want to do. But in this country, no matter whether you have a job or not, there are a lot of things that need to be done for other people, whether it is at the local level, the state level, or the federal level. There are so many things that need to be done to help the citizens of this country, and I want to convince you to do things on the side that contribute to the nation as a whole." I thought that was a strong message for the time, and, of course, it linked with his own childhood. When he and his brothers, Joe, Bobby, and Teddy, were young, their parents said to them, "We're a well-to-do family. You don't have to go into business. We want you to be in public service. Do things for the people of this country." Everybody in that family got involved with public service, and now most of the grandchildren are in public service. Some are in Congress, some are taking care of the homeless. It's a whole mentality in the Kennedy family, and that's what JFK was saying to young people in the 1960 campaign. I was impressed by that.

Six weeks or so after I'd gone to work for Jack, Bobby called me and said, "Here's a statement I think you ought to put out to the press." So I put it out. It got in the press the next day. John Kennedy called me and said, "Where did you get that statement?" And I said, "From Bobby." His temper flared. "You don't work for Bobby anymore, you work for *me* now. Only put out the statements I tell you." Although the tirade was not directed in real anger at Bobby or me, he was making it clear that now I was a John Kennedy man, not a Bobby Kennedy man.

The demands of the Senate pulled Kennedy away from his wife, Jacqueline, frequently. Their life was punctuated by airport comings and goings, such as this one in 1957.

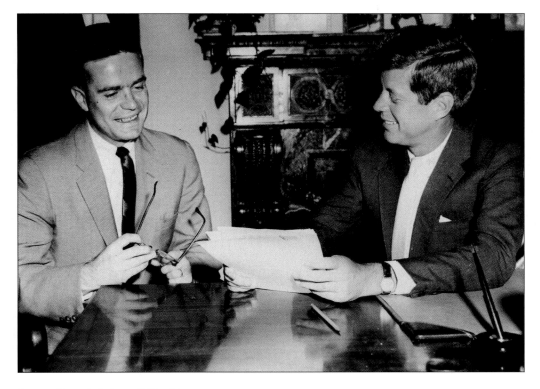

Senator Kennedy in June 1959 with policy adviser and speech writer Theodore Sorensen.

The press as an institution played an important role in the outcome of the 1960 election, and the Kennedy campaign was the first in the modern era to recognize the power of the media. I did two things that had an enormous impact on the media and made it happy collectively. First, I hired people who taped Kennedy's speeches, reproduced them in text form in twenty minutes, and handed them out to the press. That meant that the journalists didn't have to take notes. They could walk around, talk to people in the streets and get their views. They liked that a lot. I also worked it out that from the time of their arrival, they didn't have to do anything. Their bags would be turned over to us, they'd fly to the next city, they'd get to the hotel, they'd find out what room they had (we had all their rooms registered in advance), their bags would show up on time. The next morning, their bags would be taken away, put back on the plane, and taken to the next hotel. We made life easy for them. A lot of journalists covered Kennedy for a while, then covered Nixon. They would always come back to our camp and say, "It's so much more fun with you!" Professional objectivity notwithstanding, they liked Kennedy because of that. So the campaign was going well.

But a presidential campaign isn't just about campaigning. In anticipation of becoming president, the candidate must do an enormous amount of study in order to be prepared to assume the reins of power if elected. Right after JFK was nominated, we had a series of meetings at the Kennedy compound in Hyannis Port, Massachusetts. Kennedy created about ten different committees, bringing in friends, acquaintances, and recommended experts, professors from Harvard University and other places to advise him on every one of the important issues facing us—defense, foreign policy, domestic policy, and so on. These people—Ted Sorensen and many others who were to become JFK's closest advisers during the administration—were sending papers to him all the time on each of these subjects. He was getting advice during the campaign, and he was eager to learn.

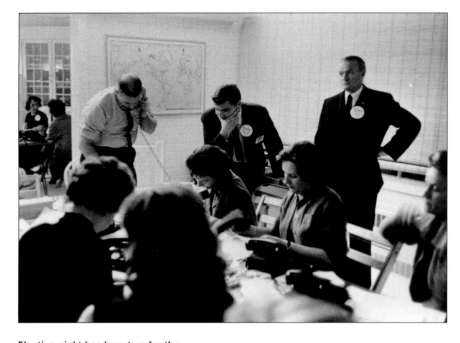

Election night headquarters for the Kennedy campaign, November 9, 1960, was Bobby Kennedy's house within the Kennedy compound at Hyannis Port. The communications center was downstairs in the enclosed porch, where telephone lines had been set up to communicate with poll watchers stationed around the country. Pierre Salinger (center) anxiously awaited poll results. The race was close throughout the night, and Senator Kennedy went to bed without knowing whether he would be president when he woke up.

ELECTION DAY

On the day of the election we gathered at Ambassador Joseph Kennedy's home to watch the returns. The mood of the campaign staff shifted hour by hour. The early returns made it look as if JFK would win in a landslide. But the big early margin disappeared in time. Jim Hagerty, President Eisenhower's press secretary, called me at midnight, however, to say that Nixon was going to concede. An hour later he called back to say that Nixon *wasn't* going to concede. The staff was furious about this, and we were anxious about the slim lead we held. But one man kept his cool—John Kennedy. He said if he were in Nixon's position he would do the same thing. He was poised, collected. He turned the television coverage off, quietly walked to his own home nearby, and went to sleep, seemingly unconcerned about whether he would wake up as the next president of the United States.

The next morning, after I'd had only an hour's sleep, an Associated Press man's phone call woke me up. He said Kennedy had carried Minnesota and that he had won the election. Whooping and hollering, not bothering to shave, I dashed over to the Kennedy compound. Ted Sorensen was already there, sitting on the edge of the tub as Kennedy bathed. Kennedy asked me if Nixon had called yet. He hadn't.

It is election day, and Senator and Mrs. Kennedy meet the press briefly with Pierre Salinger. Mrs. Kennedy was eight months pregnant at the time.

10

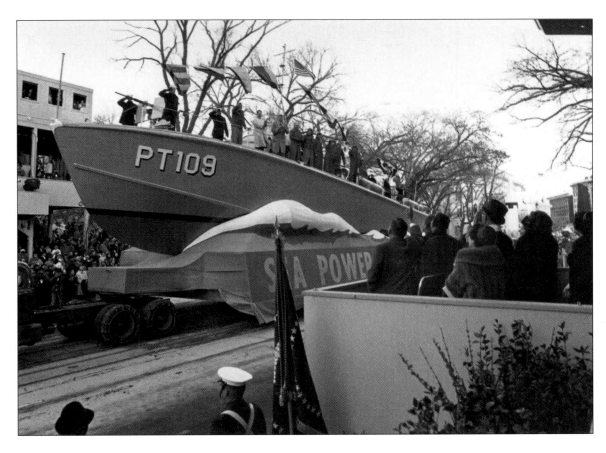

The Inauguration Parade on January 20, 1961, included this surprise—the reconstructed ship Patrol Torpedo (PT)-109, which was sunk by a Japanese destroyer while under Kennedy's command during World War II, and the surviving members of the crew, who ride on the deck.

We would not hear from him at all. At 1:00 P.M. eastern standard time, Nixon's aide Herb Klein read a concession statement to the press. To this the president-elect said, "Nixon went out the way he came in—no class."

The day after Kennedy was elected, I was the first person named to an administration office. He brought me in and said, "Pierre, you're going to be the new press secretary, all right?" I had been having some thoughts that maybe somebody else would be press secretary—Sander Vanocur's name had been brought up—although I was sure I was going to be somewhere in the government. But press secretary was the job I wanted. When I was a teenager, in fact, I had dreamed that someday I would be press secretary to a president. It turned out to be true.

An incredible journey lay before us all. The days to come were filled with hard work, much joy, much pain, and, many times, with a degree of danger that would threaten the existence of our planet. The forces aligned against us in those early years of the 1960s made for a world of near-constant tension. The new president, and everyone around him, had to deal with the new reality—that every incident had the potential to involve U.S. military forces, and that an extremely fine line between diplomacy and toughness had to be walked every day.

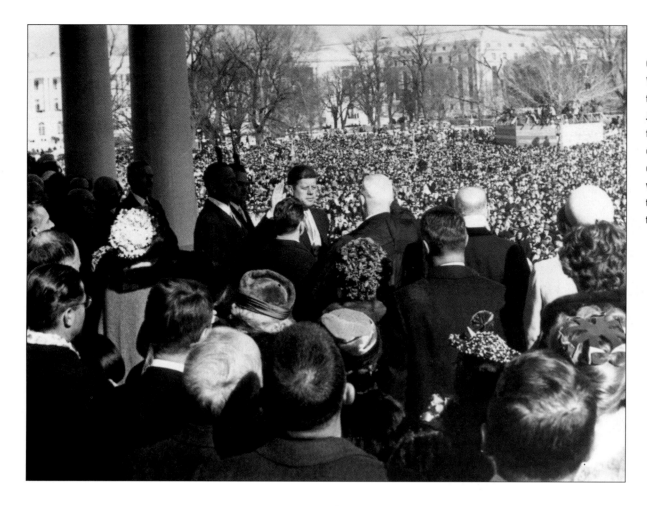

Chief Justice Earl Warren administered the Oath of Office to John F. Kennedy in front of a huge crowd on an unusually cold day. The crowd was warmed, though, by the inaugural message that followed.

The new president, John F. Kennedy, stands at the podium on inauguration day. Nearby are Mamie Eisenhower, Lady Bird Johnson, Jacqueline Kennedy, Former President Eisenhower, Vice President Lyndon Johnson, and Richard Nixon.

Perhaps because they never faced off against each other politically, Eisenhower and Kennedy seemed to respect each other. The transition of power from one administration to another was accomplished with great cooperation, which enabled the Kennedy team to be in place and functioning by the end of the first day in office. Eisenhower and his staff members continued to make themselves available to Kennedy staffers long into the new administration.

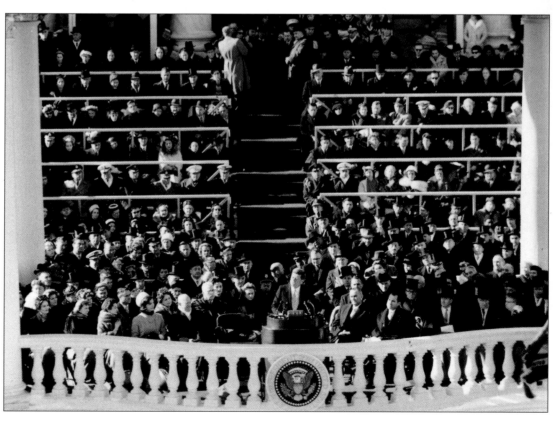

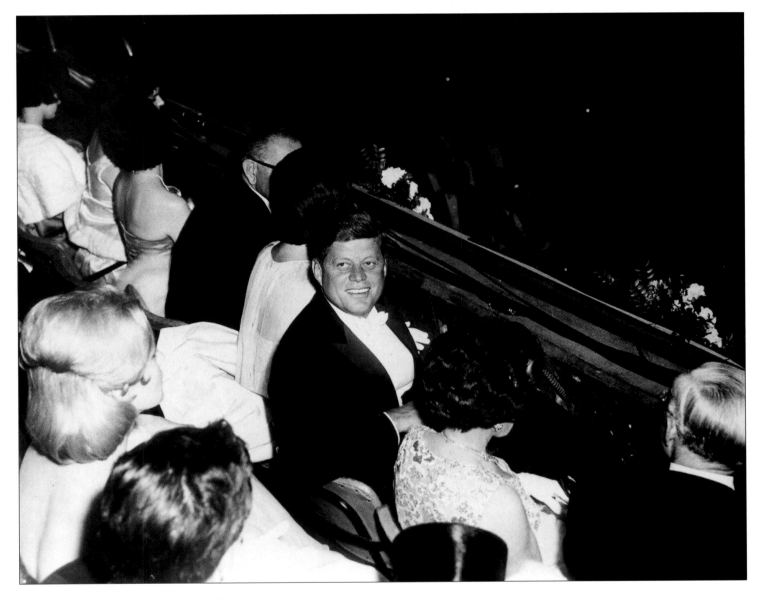

Inauguration night, January 20, 1961. President John F. Kennedy looks appropriately attired to preside over an administration that historians soon called Camelot.

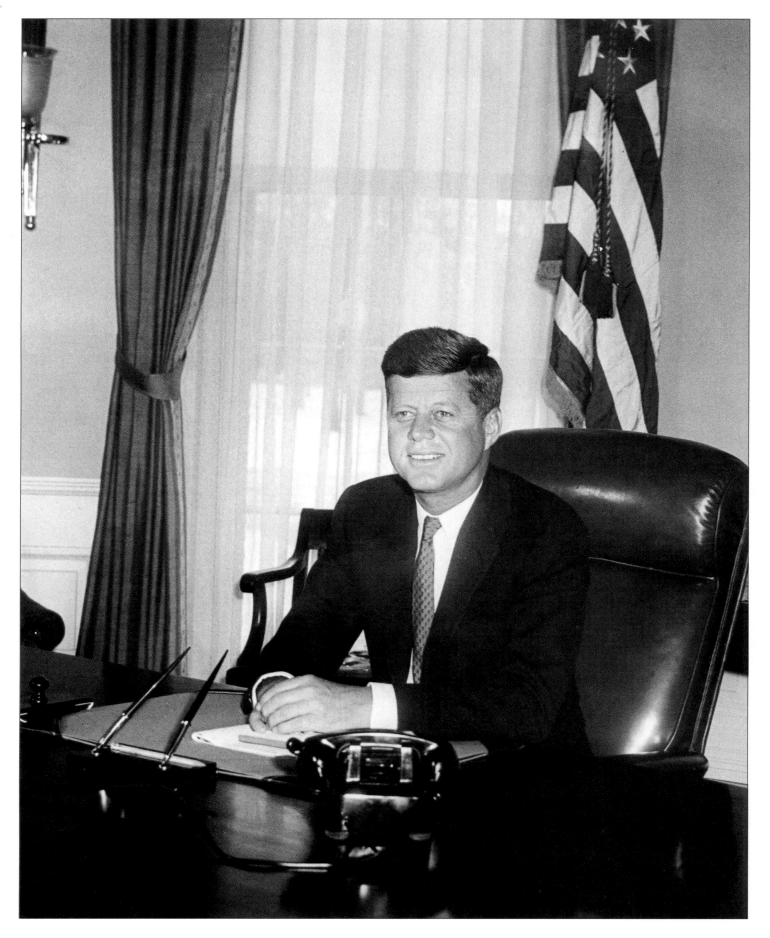

14 JOHN F. KENNEDY

★ THE KENNEDY
★ WHITE HOUSE
★

The president sat for a photograph on his first day in office, before his personal effects and work papers began to fill up his desk. This particular desk was the same one Eisenhower had used, but it did not last long. It was replaced by a desk made from the wood of the HMS *Resolute* that had been given to President Rutherford B. Hayes by Queen Victoria. It was found in the White House basement by Mrs. Kennedy, then refinished and hauled up to the Oval Office. Keen-eyed Americans noticed that it had last been used by President Franklin D. Roosevelt for his fireside chats.

The new president felt prepared and confident enough in himself to minimize the break-in period of his presidency. He did not want to ease into the Oval Office; he was up to full speed on the first day. But there were formalities to be observed, and the president allowed visitors in the Oval Office for much of his first week on the job. Old friends, the huge Kennedy family, and former presidents all came calling. The anticipation of matters at hand soon pushed pleasantries to the side. The White House machinery got into its rhythm quickly, and we were off to save the world.

Working for a president doesn't require a fourteen-hour day—it requires a twenty-four-hour day, even in trouble-free times. The staff President Kennedy pulled together for his administration, most of whom had worked in the campaign, put their collective heart, soul, commitment, and time into their new jobs. There was an urgency about the JFK White House right off the bat, not just because world affairs were urgent in those days but because each of us in his special field wanted to break new ground and do things in a newer, better way.

We were from all kinds of backgrounds, all religions, all parts of the country, but we were the New Frontiersmen, and we brought zeal to our endeavors. We would all say that those were the best jobs we ever had in our lives.

Two things led us—our idealism, and the man who embodied it, John Kennedy. There was in him a quality of leadership that I do not believe has been matched since in the White House. He was supremely intelligent, a quick study, a striver for excellence, a great judge of character, a kind man, a fearless

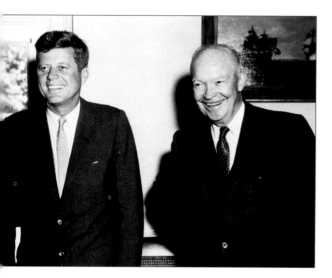

Former President Eisenhower and President Kennedy visit with each other in the early days of Kennedy's presidency. The two men were publicly cordial to each other, and Ike's staff was helpful during the transition of governments. But there was virtually nothing the two men had in common. They were from different generations and approached the job of president with different philosophies. To Kennedy, Ike was too rigid, too organized, too chain-of-command. To Eisenhower, Kennedy was naive, not ready to grasp and wield American power around the world. Their positions reflected their ages; Kennedy was at the time the youngest man elected to the presidency, Eisenhower the oldest.

Re: Kennedy

It was an important task to analyze what kind of president Kennedy might be. Eisenhower was well known and his policies were well known. Eisenhower was close to West German Chancellor Konrad Adenauer. Interestingly, we had information that Adenauer was a bit afraid about the new candidate for president, Kennedy, because he wasn't sure about his policies. As a senator Kennedy had meetings with Willy Brandt, who was the leader of the opposition party, the Social Democrats, and was an opposition candidate for chancellor. So Adenauer was not so happy at first when Kennedy won the election.

Adenauer could think that Kennedy would follow, on some points, a different policy from the one put forward by Truman and by John Foster Dulles. Adenauer had been comfortable with the policy of hard military confrontation with the Soviet bloc, and it wasn't known which way Kennedy would go. But there were some signs, some voices, that said Kennedy might look for a new way, maybe looking for peaceful coexistence.

When Kennedy became a candidate for president, Moscow pressed us for information about this man and his policies. It was a bit difficult to do. Then I thought back to my former time as a radio correspondent for foreign affairs, and I started studying the American press—*The New York Times, The Washington Post, Time, Newsweek.* Without these publications it would have been impossible to get insights into policy. It was very interesting, for example, to follow how Kennedy selected his White House staff. It was unconventional how he did it. I studied the biographies of McNamara, Dean Rusk, and so on, but we had no other information at first but newspapers. Later on, we got more detailed information from the West Germans.

The American media were very helpful to us in learning about policy, new weapons, and so on. We could use your media in many ways for our ends, but you could not use ours. But in the end it did not help us to survive.

—**Marcus Wolf**, former head of the Intelligence
Department of the Ministry of Security,
former German Democratic Republic

man, a man of action, a man with charisma and a feeling for adventure. He was a commander, pushing all the right buttons, overseeing all the details, but he had a much bigger and broader vision propelling the ship of state. We would follow him anywhere.

Among ourselves, we were not always a happy family. In the Kennedy clan of advisers were strong men of intelligence and substance, and their individual opinions were not often challenged in their fields. This made collaboration, harmony, and team play difficult. Egos clashed and arguments were constant. This fazed the president not one bit. He encouraged disagreement and debate and felt that, through them, the best advice always came to the forefront. It was a philosophy that served him well in all cases but one, and that one—the Bay of Pigs fiasco—came early, and had a solidifying effect on his approach.

Now, thirty-plus years after the Kennedy presidency, and after the end of the Soviet Union as an opposing military power, it may be difficult for many to remember how the world felt in 1961. To me, and others in the Kennedy administration, it felt as if the world were on a precipice. For nearly every day of the Kennedy presidency we felt the background tension created by having a bitter enemy constantly testing us and probing us, seemingly wanting to pick a fight at every opportunity. The Russians may have in reality been less able to wage nuclear war with us than we thought at the time, but in 1961 the concept of "irreversibility" was very much with us. Kennedy understood the dynamics of nuclear war—there was no way to rescind a bad decision, no way to recall a guided missile once the button had been pushed. The weight of the world and its unbearable expectations were always on the president. As a nation we wanted him to be tough, to stand up to Khrushchev, never to lose face or prestige for our country. But we didn't want nuclear destruction, either.

Some in our armed forces *did* want a nuclear showdown. On more than one occasion military advisers recommended, in detail, how we should preemptively strike the Soviet Union and eliminate our one big problem. The president may have even weighed his options in that regard occasionally, especially in the days of the Cuban Missile Crisis. But in the face of daily tension, JFK always kept his own calm, wise counsel. In situations where a lesser man might pull out his hair in a panic, he was lucid, deliberate, outwardly tension-free. In cabinet meetings he was always the calmest man in the room. And he always said, publicly and privately, that he would never authorize a first strike of nuclear weapons, saving them for defensive purposes only.

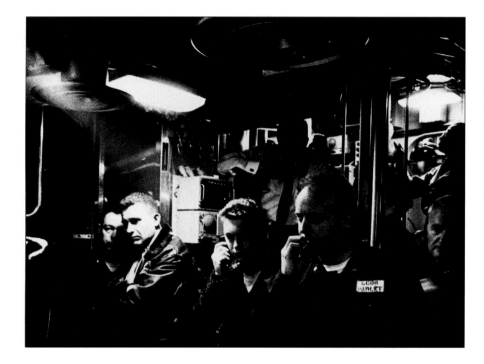

The terrifying responsibility for nuclear vigilance was borne by everyone in the nuclear chain of command, from Kennedy right down to the officers aboard Polaris submarines. Standard doctrine called for an elaborate system of redundant verifications of nuclear launch codes, plus triple oversight of the launch procedures. Here a Polaris submarine crew practices with a simulated launch order.

America's nuclear capability in the early 1960s was not limited to nuclear missiles. Nuclear delivery could be made from conventional aircraft, including several models that could take off from aircraft carriers. An aircraft carrier's Combat Information Center (C-I-C) was the place a nuclear launch directive would come first. This C-I-C from the early 1960s reflects the technology available at the time. Today, computers and digital technology have revolutionized the look and capability, but not the function, of the C-I-C.

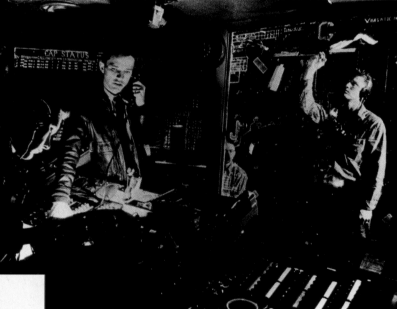

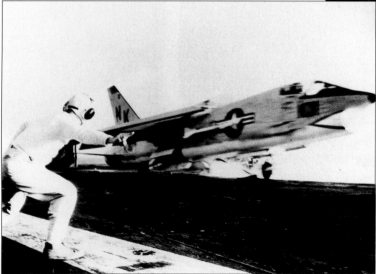

The United States Navy had no formidable adversary on the seas in the 1960s; the Soviet naval threat was in its nuclear submarine fleet. Naval aviation resources could bring the power of American jets quickly to any trouble spot on earth. The navy could launch a wide variety of aircraft from its flight decks, including heavy fighter bombers that had nuclear capability. This quick-strike aviation capability was more fully developed in later decades.

THE MILITARY/FOREIGN POLICY ADVISERS

Advising the president on defense, military, and foreign policy matters in a near–war room daily atmosphere were dozens of men—from each of the services, from the Joint Chiefs of Staff, from the Central Intelligence Agency (CIA), from the armed service secretaries, from the State Department, but, most importantly, from Kennedy's own inner circle. Many were from Harvard, giving rise to the label "eggheads," but nothing could have been further from the truth. Ken O'Donnell, for example, was appointments secretary and a Harvard man. He was also the former captain of the Harvard football team, an All-American, and a tough Irishman from street-level Massachusetts politics. He was as far from an egghead as you can get. Of all JFK's advisers, O'Donnell had the most pervasive influence on the president, in my opinion. Forget the title—Ken was a bright, objective thinker, and JFK relied on him in all matters.

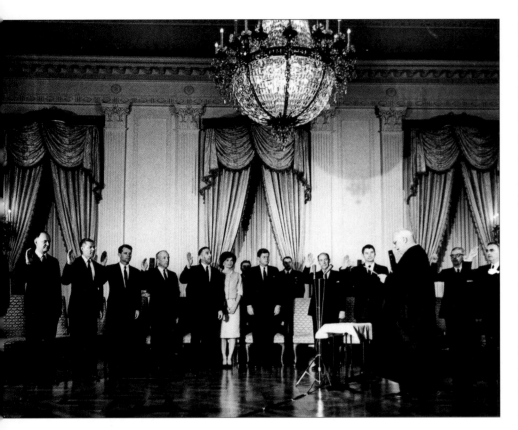

Chief Justice Earl Warren swears in the Kennedy cabinet en masse, with the president and Mrs. Kennedy attending. From left to right are Dean Rusk, Secretary of State; Douglas Dillon, Secretary of the Treasury; Robert McNamara, Secretary of Defense; Robert Kennedy, Attorney General; J. Edward Day, Postmaster General; Stewart Udall, Secretary of the Interior; Mrs. Kennedy; President Kennedy; Adlai Stevenson, Ambassador to the United Nations; Orville Freeman, Secretary of Agriculture; Arthur Goldberg, Secretary of Labor; and Abraham Ribicoff, Secretary of Health, Education, and Welfare.

Some of us—Ted Sorensen and I, for example—were from neither Harvard nor the Irish-Catholic milieu. Ted was one of the three other men besides O'Donnell who had a premier position with JFK—the others being his brother Bobby and McGeorge Bundy. Ted had been with Kennedy since 1953, when he was a staffer for the newly elected Senator Kennedy. In the new administration Sorensen had many duties, but primarily he was a policy formulator, especially on domestic issues, and a speech writer nonpareil. He had a deft hand at phrasing things with just the right blend of impact and substance. He knew Kennedy's speech patterns and, having been with him so long, his philosophy and positions on most issues.

McGeorge Bundy, you may have read, was an austere academic, an outsider to the rest of the staff because he was a Republican and he had not been part of the campaign. Those labels are not correct. He was definitely an insider, perhaps not loved by all, but a charming man under the surface and incredibly bright. Mac was JFK's ranking

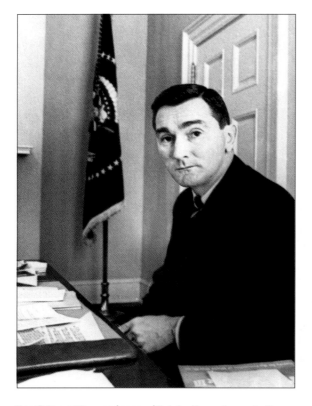

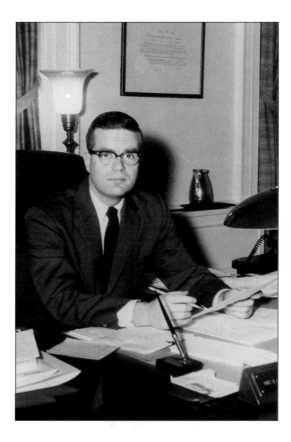

Ted Sorensen was a key staff member in the Kennedy White House, serving in many important roles but principally as a domestic policy formulator and chief speech writer. Having been with the president since his election to the Senate, Sorensen had an instinct for Kennedy's politics and the skills to translate them into eloquent language that reflected the president's own manner of speaking.

Ken O'Donnell's experience with John Kennedy went all the way back to precinct organizing in the senatorial campaign of 1952. From those days forward O'Donnell was more than just a staffer—he was a thoroughly trusted adviser, intimately involved in all aspects of Kennedy's political life. After the inauguration, O'Donnell became Kennedy's appointments secretary, which meant that the only way to get to Kennedy was through him. But his duties were actually far more broad than that. He was the liaison between Kennedy and the Secret Service and the FBI and took care of all the president's travel arrangements. He was the insider's insider, one of the few men in Washington who took his orders directly from the president.

McGeorge Bundy left his post as dean of the Faculty of Arts and Sciences at Harvard University to become President Kennedy's special assistant for national security affairs. Acknowledged throughout the political world as a brilliant analyst and strategist, Bundy also assembled a large staff of national security specialists who in aggregate became a kind of shadow state department; in fact, Kennedy referred to Bundy's group as the "little state department." Regarded by some as a haughty man, and a Republican to boot, Bundy nonetheless was as deep in the inner circle of Kennedy advisers as one could go. Kennedy relied heavily on his counsel throughout the national security crises of his presidency.

President Kennedy's three military aides. From left: Maj. General Chester V. Clifton, USA; Brig. General Godfrey T. McHugh, USAF; Captain Tazewell Shepard, USN. One of these military aides was with Kennedy all the time.

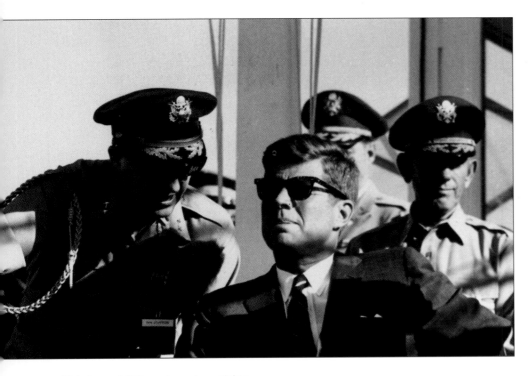

Maj. General Clifton, shown here giving the president the details of a missile firing test at the White Sands Missile Range (WSMR) in June of 1963, was arguably President Kennedy's most prominent military aide.

adviser on foreign affairs. Bundy had his own staff of specialists who were experts on a variety of topics. The key staffers were Carl Kaysen, Mike Forrestal, and Robert Komer. Using these considerable assets, Bundy held a daily morning briefing on world affairs for key staffers.

Arthur Schlesinger was another trusted adviser, whose official job of White House liaison to United Nations Ambassador Adlai Stevenson did not begin to define his greater role. As an historian of great repute, and a personal friend of Kennedy's, his counsel on defense issues was greatly respected by the president.

The president also had a close relationship with the three men who would work most closely with him on military matters—Army Maj. General Chester V. Clifton, Navy Captain Tazewell T. Shepard, and Air Force Brig. General Godfrey T. McHugh. Each had been chosen personally by Kennedy to represent his respective branch of the armed services, and therefore each had a great feeling of loyalty to him above and beyond his rank as commander in chief.

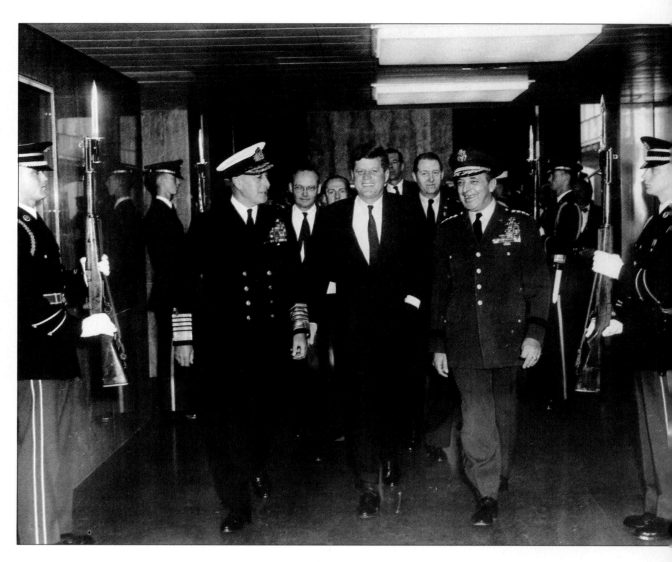

General Lyman Lemnitzer, chairman of the Joint Chiefs of Staff, flanks President Kennedy at the April 1961 NATO meetings. To Kennedy's right is Great Britain's Lord Mountbatten.

These three men weathered the basic tension of their duties with great aplomb, serving the president to their utmost ability while always being pressured by their superiors in their respective services to get a leg up on their interservice rivals or get the president's ear on a particular defense appropriation. Ted Clifton may have had a slight edge over the others for overall influence. He was with the president daily, both in Washington and on the road, giving him his military intelligence briefing. But Captain Shepard and General McHugh were equally capable and, like the rest of us, felt allegiance to the president above all other things.

The extended cast of defense-related characters included the Joint Chiefs of Staff, headed by its chairman, Army General Lyman Lemnitzer; Secretary of Defense Robert McNamara and his second in command, Roswell Gilpatrick; Allen Dulles, director of the CIA; Secretary of State Dean Rusk; General Maxwell Taylor, later chairman of the Joint Chiefs; the president's brother, Bobby; Vice President Lyndon Johnson; and advisers Larry O'Brien and Dick Goodwin.

McGeorge Bundy goes over some details with the president on the way to a press conference, August 9, 1962.

The president and his military adviser, Maxwell Taylor, visit with General Earle Wheeler in the Oval Office. Wheeler was the chief staff officer for the Joint Chiefs of Staff and, later, army chief of staff.

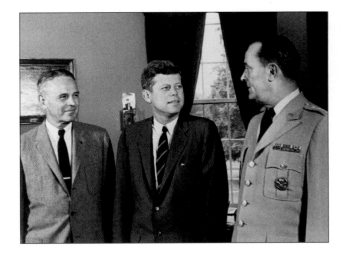

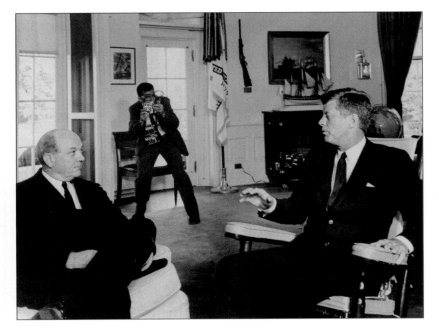

President Kennedy's relationship with the State Department was considered to be the strongest in recent American history, perhaps as a result of the turbulent foreign policy events of his presidency but more likely as a result of Kennedy's emphasis on America's international role. Dean Rusk, who had been serving as president of the Rockefeller Foundation before being asked to become secretary of state, managed the department in these tumultuous years. Although he and Kennedy did not know each other well prior to this time, he became an integral part of the cabinet. His role was abetted, however, by McGeorge Bundy. Inevitably, there were frictions and turf battles between Bundy's and Rusk's groups. But Rusk had the confidence of the president, who chided Rusk gently only when he wished the secretary would express his opinions more forcefully.

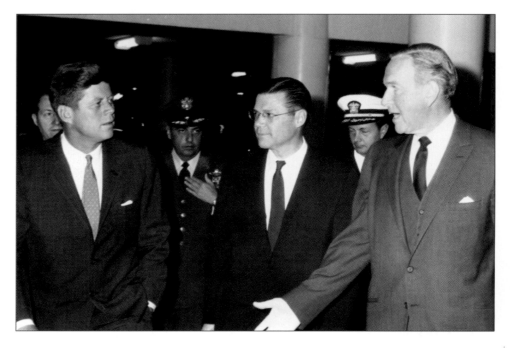

On April 26, 1963, President Kennedy came to the Pentagon, where he was to address a group of high-ranking defense and civilian officials. Robert McNamara (center) and Deputy Secretary Roswell L. Gilpatrick accompanied him, as did the president's military aides; in the background, left to right: Maj. General Clifton (behind Kennedy); Brig. General McHugh; and Captain Shepard.

A DAY IN THE OVAL OFFICE

There was no shortage of opinion in the Kennedy White House. Just managing the flood of advisers' opinions was a full-time job for the president. On a typical day, he would get up at 7:00 A.M., and by eight, accompanied by Mac Bundy, he would have had briefings from the CIA and possibly General Clifton. This was called the Intelligence Check List. We were in a cold war, and the president was very focused—I would say 60 percent to 70 percent—on foreign policy/defense issues. The Check List was highly secret, for the president's eyes only. It was a summary of the previous twenty-four hours' global activities. From this list the president would issue orders for action that either Bundy or Clifton would set in motion.

Later in any given day, regulated by O'Donnell, the tide of advisers, congressmen, cabinet secretaries, and assorted guests would begin. Once inside the Oval Office, visitors would look around at a motif that revealed a bit about the president's own military history. JFK was a navy man and always loved to sail. His office had a nautical theme, starting on the mantel, with a scale replica of his World War II ship, the PT-109. Robert Donovan's book *PT-109* had popularized the now-familiar story of Kennedy's heroics in the South Pacific while commanding a PT boat. The president was a bit reticent about his World War II adventures, especially after the book came out, but had actually exploited them a bit during the campaign, when he had tie pins made up in the shape of the PT-109. (I still have mine, and it is one of my most prized possessions.) He would hand them out to campaign supporters, as he understood the political value of his storied military career. The scale model of that ship was accompanied on the mantel by an ivory ship model given to him by Nikita

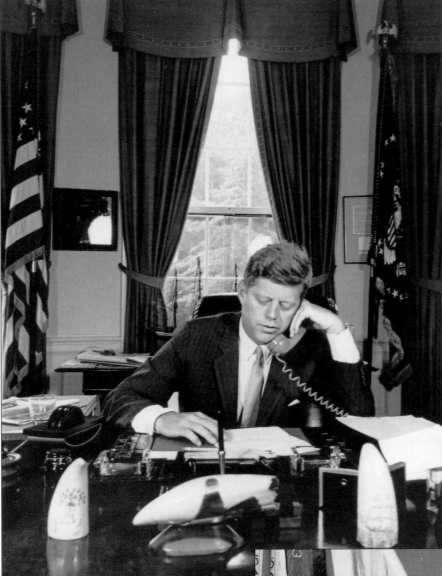

The president's desk overflowed with mementos, gifts, and personal belongings. Among the artifacts was a set of scrimshawed whale teeth, a gift from Kennedy friend K. LeMoyne Billings; an inaugural medal given to the president by the inaugural committee; a cut-glass ashtray from Ireland, a gift from Ethel Kennedy's friend Dot Tubridy, of Dublin; and the coconut shell on which Kennedy had scrawled an SOS during his PT-109 adventure in the Solomon Islands.

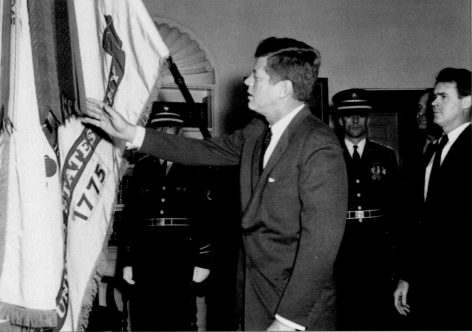

Secretary of the Army Cyrus Vance and Army Chief of Staff Earle Wheeler present the official army standard to President Kennedy in a White House ceremony on December 17, 1962. The flag was to be kept at the White House as long as Kennedy was president, but he would be free to take it with him when he left office. The flag has 145 campaign ribbons that date back to 1775.

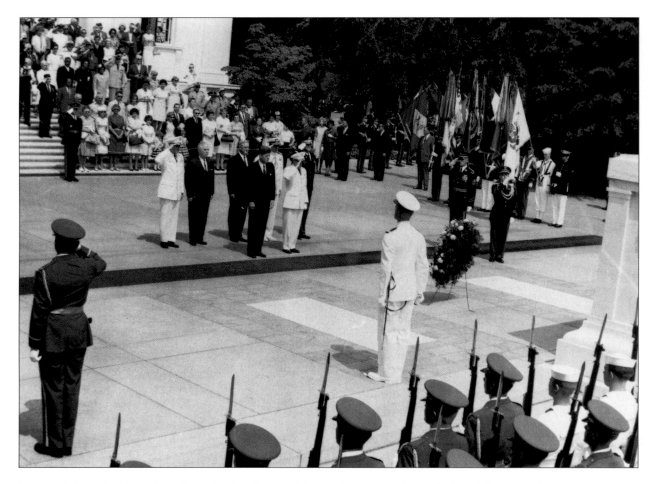

On May 30, 1963, President Kennedy presided at the Wreath Laying Ceremony at the Tomb of the Unknown Soldier, Arlington National Cemetery. Despite Kennedy's mistrust of military commanders—a mistrust that turned to something like feelings of betrayal after the Bay of Pigs—he had a deep respect for regular soldiers, sailors, and airmen.

Khrushchev. On the walls were paintings of great naval battles and a plaque presented to him by Admiral Hyman Rickover. On his desk sat the coconut shell on which he wrote "SOS" after his PT-109 was sunk by a Japanese destroyer. Also on the desk were bookends in the shape of cannons used on the USS *Constitution* (Old Ironsides). Behind his desk were the flags and battle streamers of the army, navy, air force, and Marine Corps.

The president was far from a "hawk," but, as his office attested, he was proud of his own military service and had great respect for the military in general. Despite later serious difficulties with the Joint Chiefs and military establishment, the president never let his admiration for men and women in uniform waver.

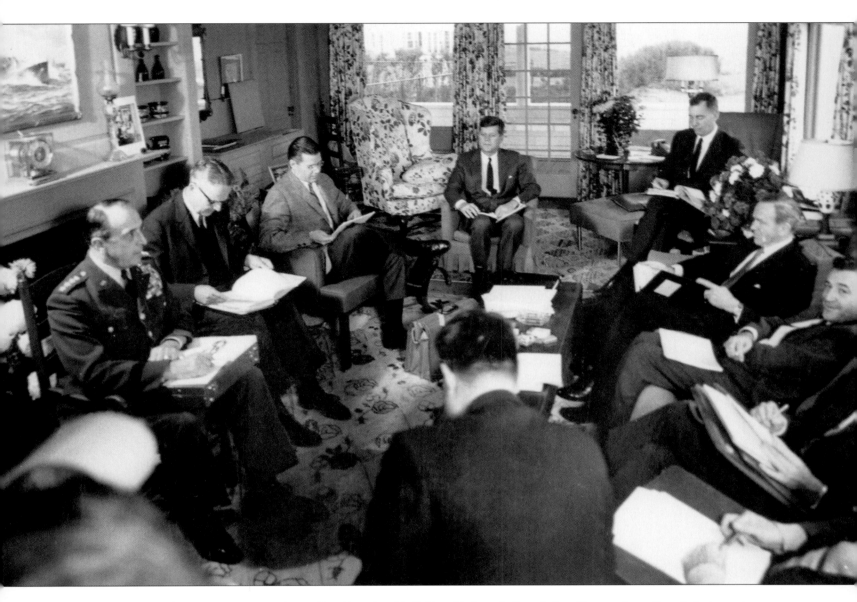

President Kennedy presides over a budget meeting, held on November 24, 1961, at his home in Hyannis Port. The complex at Hyannis Port served as a second White House. It was not unusual for the president to have working weekends there, combining meetings with golf and sailing outings.

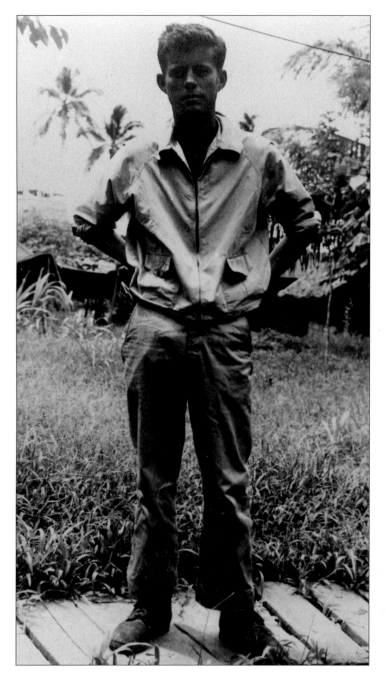

Lt. Kennedy somewhere in the Solomon Islands, 1943.

LT. JOHN F. KENNEDY, USN

The president's military career and mine were similar, in that we both served in the navy in the South Pacific and had won the same medal—the Navy–Marine Corps Medal. Mine was won by swimming a line to stranded sailors during a typhoon. The president kidded me about that all the time, saying he had won his fighting the enemy, while I had merely fought the elements. The president's own accomplishments as a war hero were well documented and his decorations well deserved. Personal courage was the attribute Kennedy most admired in others, and his own behavior and actions in the South Pacific exemplified it.

The navy's Captain Conklin presents the Navy-Marine Corps Medal to Lt. John F. Kennedy on June 11, 1944, at the Chelsea Naval Hospital. The medal was awarded to Kennedy for his valiant efforts to save the lives of his crewmen after the PT-109 was sunk by a Japanese destroyer in the Solomon Islands, a story that was later written into the book and film *PT-109*. The war had clearly left the future president thin and tired.

This group photo is of Kennedy's PT boat training school class in October 1942. Kennedy is in the back row, seventh from the right.

The crew of the PT-109, with its commander, Lt. Jack Kennedy (far right), posed for this picture while the boat was undergoing repairs somewhere in the South Pacific.

The future president is smiling here by the doors of Chelsea Naval Hospital, where he had gone to recuperate from the war in June 1944.

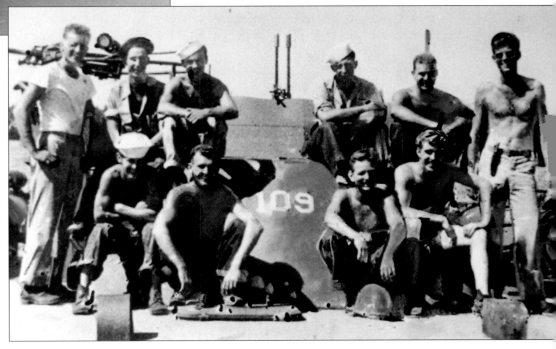

This group of navy buddies posed for a picture at the naval base at Tulagi, Solomon Islands, in 1943. Each man would continue his relationship with Kennedy (second from left) until his death. At far left is George "Barney" Ross, who is remembered at the White House for arranging the September 25, 1962, reunion between Kennedy and the man who rescued him during World War II, the Solomon Islands native Ben Kevu. Paul "Red" Fay (second from right) would be called to Washington by Kennedy to serve as undersecretary of the navy. Jim Reed (far right), an old Massachusetts friend and comrade in arms, was named assistant secretary of the treasury in charge of customs and the Coast Guard.

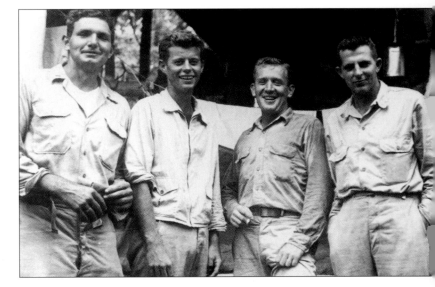

Press Secretary Pierre Salinger

My Duties in the White House

My office was near the Oval Office, across the hall from the Cabinet Room. What the president wanted was for me to have total access to him. I saw him six, seven, eight times a day. When anything came up, such as a hot piece from the wire services, I would go see him immediately. I traveled with the president all the time. In three years I may have missed two or three trips. Even when he was on holiday, I was with him, every time.

Each morning I tried to get to the White House no later than eight o'clock. I would go see Mac Bundy first, to find out what was going on in the world. I'd go see Sorensen, then Larry O'Brien, then Walt Rostow, who worked for Bundy at the National Security Council and served as deputy special assistant to the president for national security affairs and who, like Bundy, digested raw intelligence data sent over daily by the CIA. We did not have a daily staff meeting like many White Houses did.

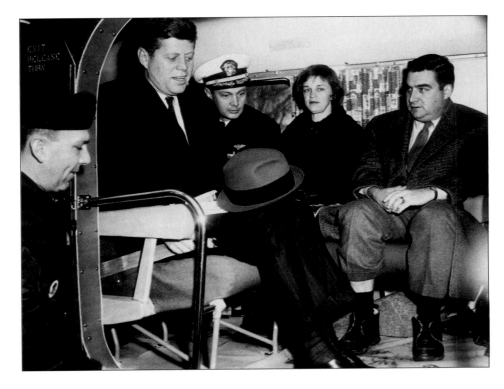

Salinger's duties called for near-constant access to the president. Here the two men are delivered to the White House lawn in April 1961 by army helicopter.

We briefed each other personally or in small groups. This dynamic had been set in place on day one.

During the transition of power from Eisenhower to Kennedy, Eisenhower had made himself available to the president-elect on several occasions. On one of Kennedy's visits, Ike and Kennedy talked briefly about foreign policy and defense matters. One of those matters was the covert operation under U.S. supervision involving Cuban nationals and their attempt to overthrow Fidel Castro in Cuba. Kennedy had first heard of it a week after the election, in Hyannis Port, where we all had gone to organize the transition. Allen Dulles and his deputy director, Richard Bissell, had come to brief the president-elect on many things and had mentioned the Eisenhower plan to train the Cuban insurgents in Guatemala. It was duly noted by Kennedy . . . nothing extraordinary.

He would soon find out how devastating a miscalculation this would turn out to be.

Vice President Lyndon Johnson was not really JFK's kind of man. His selection for the 1960 ticket had been strategic for Texas votes, and it had paid off. The "best and brightest" bunch of Kennedy Ivy Leaguers were wont to make fun of the drawling Texan, but Kennedy always reminded them of Johnson's importance—and how best to use him. Kennedy himself used Johnson to great symbolic effect on two occasions—the Vietnam trip of May 1961, during which Johnson delivered the president's message of increased support to President Ngo Dinh Diem; and the Berlin trip of August 1962, during which Johnson delivered both a buoyant message of hope to frightened Berliners and a letter from Kennedy to West Berlin Mayor Willy Brandt asking him to knock off the criticism of U.S. policy.

The ceremonial duties of a president and commander in chief, especially those involving visiting foreign dignitaries, often included the formalities of military honor guards and reviews on the White House lawn. Colonel John W. Goru served as commander of the honor guard.

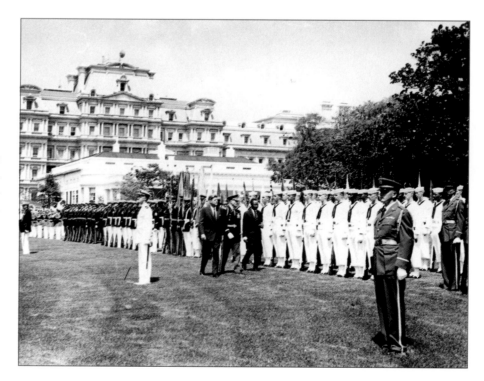

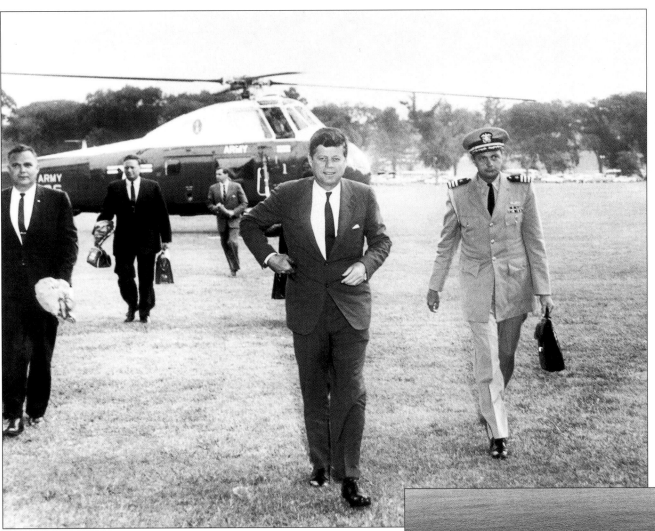

The president and Captain Shepard (right). A briefcase containing Emergency Action Documents, the so-called football, is carried by another military aide. These dozens of documents contained codes necessary for the president to set in motion the launch of nuclear weapons all over the world. The football was within two minutes of the president, day or night, throughout his presidency. The codes enabled him to stop the missiles as well, a fact that loomed in importance when he discovered, in January 1961, that subordinate commanders at the Strategic Air Command (SAC) claimed the power to launch U.S. missiles on their own initiative if they could not reach the president quickly enough.

Polaris submarines represented a clear nuclear advantage for U.S. forces in the cold war. These advanced ships of the navy's Fleet Ballistic Missile class of subs were nuclear-powered and carried nuclear warheads on their missiles. They could reach speeds of 20 knots and descend to depths greater than 120 meters. The second generation of Polaris missiles, the A-2s, which became operational in 1962, were carried in the Ethan Allen and Lafayette class of subs.

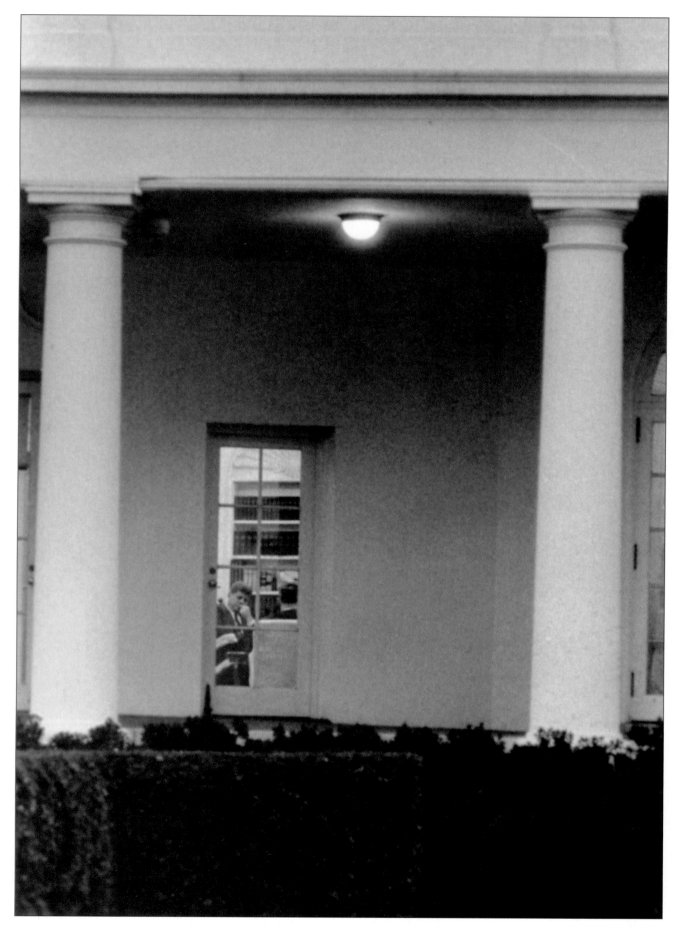

CHAPTER TWO

★ THE BAY OF PIGS

The president shouldered the blame for the Bay of Pigs alone. The political consequences, however, were negligible. The American people were either unaware of or unconcerned about the debacle; the president's first-quarter approval rating stood at 82 percent.

The nature of my job—being the link between the president and the global news media—put me in contact with the most curious, cynical people in the world: reporters. At any given time I could be quizzed by a reporter about any White House activity, any covert operation in progress, or any highly sensitive negotiation in progress. It was not unusual to be questioned on matters about which the reporters had more information than I did. Sometimes my lack of knowledge, especially on sensitive defense issues, was the result of a strategic decision made at higher levels to prevent leaks. After all, there is no better way to keep a secret than by not telling anyone.

A HINT OF TROUBLE IN CUBA

That was the situation on April 16, 1961, just three months after Kennedy took office. I was extremely busy but had not been present at any top-secret meetings of any importance to date. The president called me and said that he wanted me to stay at home that evening, and that if I had press inquiries about a "military affair in the Caribbean," I was to say that I knew only what I had read in the newspapers. His voice had a gravity that I had not heard before.

The words "military affair in the Caribbean" could mean only one thing—Cuba, probably something to do with the rumored invasion of the island by ex-iled Cuban nationals. It really was not much of a secret. Six months earlier there had been reports in the Guatemalan newspaper *La Hora* about the training under way of a Cuban brigade by U.S. military advisers. *The New York Times*

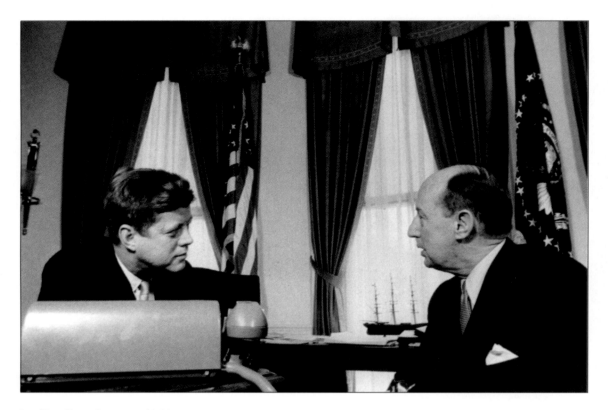

President Kennedy meets with his ambassador to the United Nations, Adlai Stevenson, in March 1961. Kennedy and Stevenson had been political rivals for years, but the president acknowledged Stevenson's experience. Less than a month after this picture was taken, Stevenson found himself unwittingly denying the U.S. position regarding the invasion of Cuba on the floor of the United Nations, not knowing until later that his assertions were lies. Stevenson rightly felt his integrity had been compromised, and the Kennedy administration strove mightily in the months ahead to placate him.

Ambassador Stevenson, in good faith, told the United Nations that the pilots had apparently "defected from Castro's tyranny." The subsequent disclosure of the truth was very disturbing to Stevenson, who felt his integrity had been compromised. The fallout from this personal injury was just one of the disasters of the Bay of Pigs.

I am not privy to the events that led to the U.S. decision to be party to the invasion of Cuba, nor was I present when the CIA and military advisers briefed the president on the military plans and contingencies. Arthur Schlesinger, among others, discusses these details in his book *A Thousand Days.* But I do know that the three days from April 17 to April 19, 1961, were among the darkest of the JFK presidency.

On the morning of April 17, a Monday, the president gave me the party line: "We'll have no comment on what's happening down there. We're watching developments down there—that's all." The ill-fated invasion started that day. I had a rough three or four days with the press, but since I didn't know anything, I didn't get pounded too hard. By today's standards the press wasn't in a feeding frenzy at all. My time was spent running wire service flashes into the president's office. When it became clear that the whole event was going badly, the president would read the dispatches quickly, then hand them back to me disgustedly.

Nikita Khrushchev took full political advantage of America's blunder at the Bay of Pigs, using it in an effort to convince the world that the United States wanted to invade Cuba. This was Kennedy's reply to the Soviet premier, dated April 18, 1961.

Dear Chairman:

You are under a serious misapprehension in regard to events in Cuba. For months there has been evident and growing resistance to the Castro dictatorship. More than 10,000 refugees have recently fled from Cuba into neighboring countries. Their urgent hope is naturally to assist their fellow Cubans in their struggle for freedom. Many of these refugees fought alongside Dr. Castro against the Batista dictatorship; among them are prominent leaders of his own original movement and government.

There are unmistakable signs that Cubans find intolerable the denial of democratic liberties and the subversion of the 26th of July Movement by an alien-dominated regime. It cannot be surprising that, as resistance within Cuba grows, refugees have been using whatever means are available to return and support their countrymen in the continuing struggle for freedom. Where people are denied the right of choice, recourse to such struggle is the only means of achieving their liberties.

I have previously stated, and I repeat now, that the United States intends no military intervention in Cuba. In any event of any military intervention by outside force we will immediately honor our obligations under the inter-American system to protect this hemisphere against external aggression. While refraining from military intervention in Cuba, the people of the United States do not conceal their admiration for Cuban patriots who wish to see a democratic system in an independent Cuba. The United States government can take no action to stifle the spirit of liberty.

I have taken careful note of your statement that the events in Cuba might affect peace in all parts of the world. I trust that this does not mean that the Soviet government, using the situation in Cuba as a pretext, is planning to inflame other areas of the world. I would like to think that your government has too great a sense of responsibility to embark upon any enterprise so dangerous to general peace.

I agree with you as to the desirability of steps to improve the international atmosphere. I continue to hope that you will cooperate in opportunities now available to this end. A prompt cease-fire and peaceful settlement of the dangerous situation in Laos, cooperation with the United Nations in the Congo, and a speedy conclusion of an acceptable treaty for the banning of nuclear tests would be constructive steps in this direction. The regime in Cuba could make a similar contribution by permitting the Cuban people freely to determine their own future by democratic processes and freely to cooperate with their Latin American neighbors.

I believe, Mr. Chairman, that you should recognize that free peoples in all parts of the world do not accept the claim of historical inevitability for Communist revolution. What your government believes is its own business; what it does in the world is the world's business. The great revolution in the history of man, past, present and future, is the revolution of those determined to be free.

Sincerely,

John F. Kennedy

informed the president that the cause was lost unless the United States contributed its own forces and material assets to the operation. Kennedy would not do this. And so the military adventure reached its bitter end. Cuban forces killed or captured nearly all of the invaders, and then Castro claimed victory over the United States. Five of us gathered in the Oval Office at 2:00 A.M.—Arthur Schlesinger, Dick Goodwin, McGeorge Bundy, the president, and I. We discussed the situation for half an hour. Kennedy suddenly left us, walked through the doors to the south lawn, and spent a solid hour out there alone, pacing. We could see him occasionally passing by the windows. It was a picture of loneliness.

THE LESSON LEARNED

The president, to his credit, did not shift blame for the Bay of Pigs to anyone else. After deflecting most Cuban questions from the press by saying, "I know many of you have further questions about Cuba, but I do not think that any useful national purpose would be served by my going further into the Cuba question this morning," he said two important things. The first was his now-famous line, "There's an old saying that victory has a hundred fathers and defeat is an orphan." If that statement didn't make it clear he was taking the blame, he followed it with, "I am the responsible officer of this government." In private he was even clearer. He said to anyone who asked, "I made this mistake, and I take full responsibility for it." The following spring the president took further responsibility behind the scenes, getting most of the captured rebels returned safely to the United States in exchange for food and medical supplies. This was a very small measure of recompense to those brave soldiers, and it made us all feel slightly better about the whole thing.

In December 1962, after the United States delivered over $50 million worth of medicine and food to the Castro government, the Cubans released captured members of Brigade 2506, the American-trained Cuban unit that made up the bulk of the invasion force. A rally for these men and their families was held in the Orange Bowl in Miami on December 29.

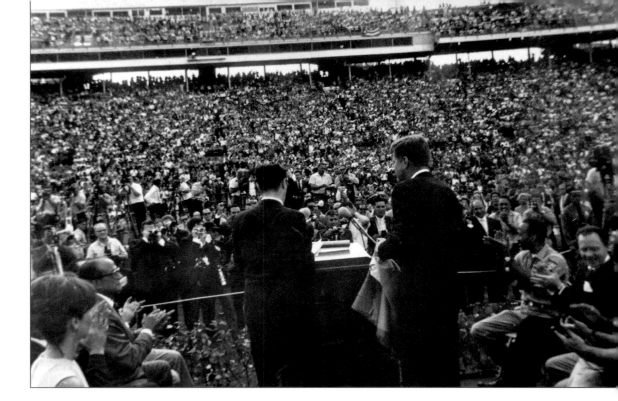

From a convertible, the president and Mrs. Kennedy talked with José Perez San Ramon, the military commander of Brigade 2506, Manuel Artime, civilian leader of the brigade, and José Miro Cardona, former president of Cuba and a leader of the anti-Castro movement in south Florida.

President Kennedy was invited to address the crowd, expected to be forty thousand strong. There were warnings from his staff. What if the men were angry at Kennedy for botching the invasion, and booed him, or worse? But Kennedy was determined to go, feeling he owed them his presence. The president strode to the podium set up on the football field . . . and heard nothing but enthusiastic cheers. He and Mrs. Kennedy, who accompanied him on the trip, were moved by the show of support.

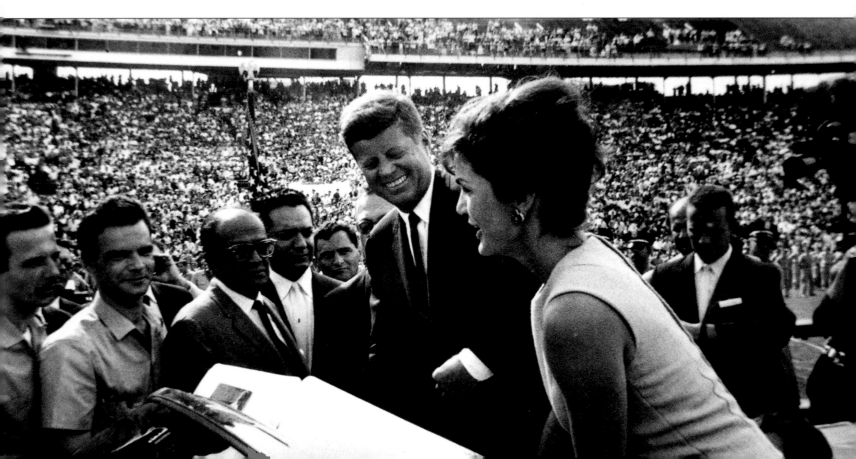

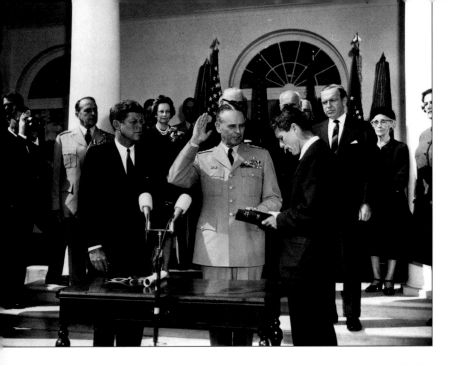

General Taylor replaced General Lemnitzer as chairman of the Joint Chiefs of Staff in 1962. Attorney General Robert Kennedy swears in the new chief in a White House ceremony. Though not an official staff member for the first half of 1961, Taylor had been a trusted military adviser to Kennedy, and had left the chairmanship of Lincoln Center in New York to chair the panel that examined the role of the CIA in the Bay of Pigs operation. In many ways Taylor was the embodiment of Kennedy's ideal soldier—a linguist, an historian, a man who exhibited none of the clichés of military power or rank.

The real payoff for Kennedy was in what he learned from the disaster. After the Bay of Pigs, the president set up a commission, including Bobby Kennedy and General Maxwell Taylor, to look into what caused such a mistake. What came out, finally, was that the president had been dealing with CIA agents and with people in the Defense Department and the Pentagon whom he did not know. He did not have any background with them, so he had not had a real dialogue with them. He had not felt comfortable questioning them on why we should do this or why should we do that. The president's overall conclusion was simple. If we got into a crisis again, his advisers would be people who had been around him for a long time, that he trusted, that had good ideas. If we're going to fail, he said, we'll do it acting on our own advice to each other.

The Cuban Missile Crisis of the following year was the opportunity to put to good use the lessons of the Bay of Pigs. With a lot more at stake, perhaps the fate of the world, President Kennedy decisively and thoroughly questioned every bit of military advice dozens of times and brought nearly everyone in the administration into the loop of decision making. At that crucial moment in time, the wisdom that came from the Bay of Pigs experience made it almost seem worth it.

Politically, the Bay of Pigs had no real domestic effect. About two weeks after, a Gallup poll came out saying the president had the support of 82 percent of the American people. He called me in his office and said, "Pierre, did you see the poll?"

I said, "I sure did, Mr. President."

He said, "I hope I don't have to keep doing stupid things like that to remain popular."

Former President Eisenhower and President Kennedy met on April 22, 1961, at the presidential retreat, Camp David. It was Kennedy's first trip to Camp David, which had been named for Eisenhower's grandson. The topic of discussion this day was the Bay of Pigs.

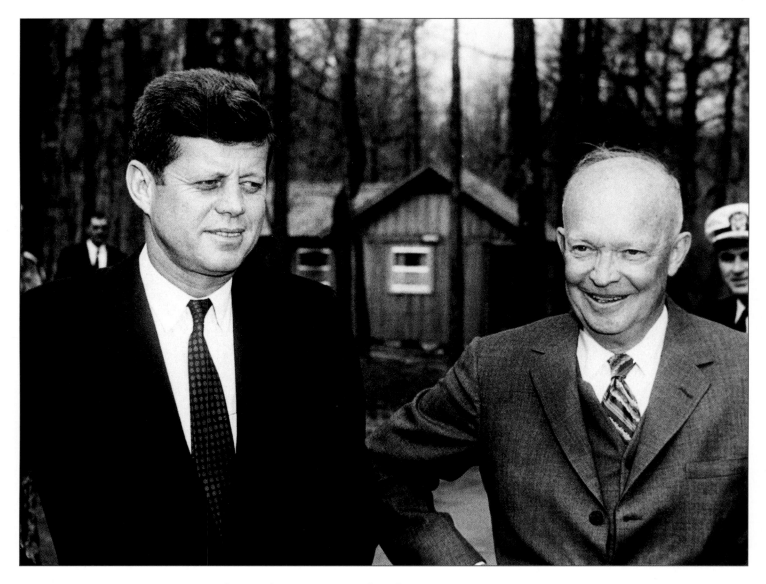

Over the course of a long walk, Kennedy candidly described the panoply of failures in the Cuban adventure to Eisenhower, the man who had overseen the largest amphibious assault in human history. As General Taylor had been earlier in the day, Eisenhower was flabbergasted to hear of the sloppy planning that had preceded the Bay of Pigs. As the two men walked the grounds, Ike lectured the young president not only on the hows and whys of this kind of military operation but on the executive responsibility Kennedy had to assert over all his advisers, and especially the Joint Chiefs of Staff. It was nothing short of a scolding from the older man, and it raised Kennedy, already angry at the whole situation, to new heights of ire. Back in Washington that afternoon Kennedy vented his spleen on anyone who would listen, vowing to rein in the chiefs' power by relying only on his inner circle of advisers, and to get rid of "the CIA bastards," Allen Dulles and Richard Bissell.

The army-navy football game, December 2, 1961, in Philadelphia. At halftime, the president walked toward the navy side of the field between rows of army and navy cadets. As he neared the navy sideline, the midshipmen chanted, "Welcome home, welcome home."

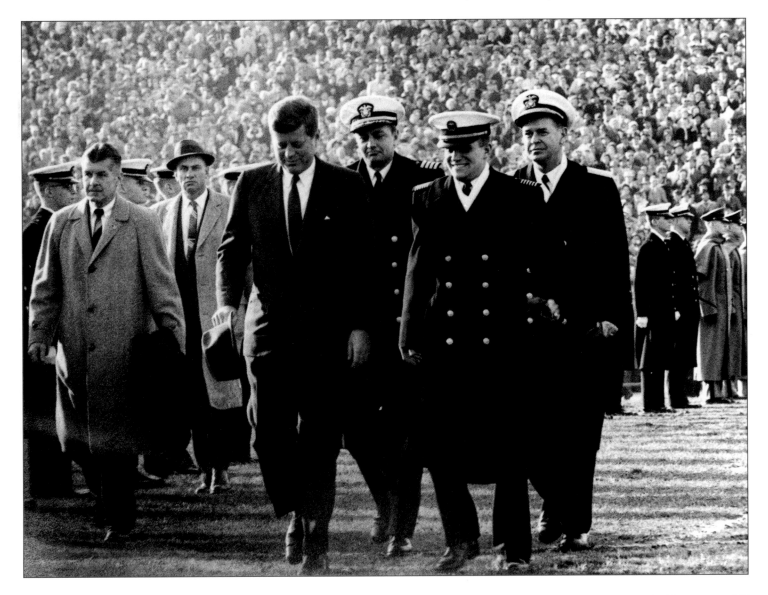

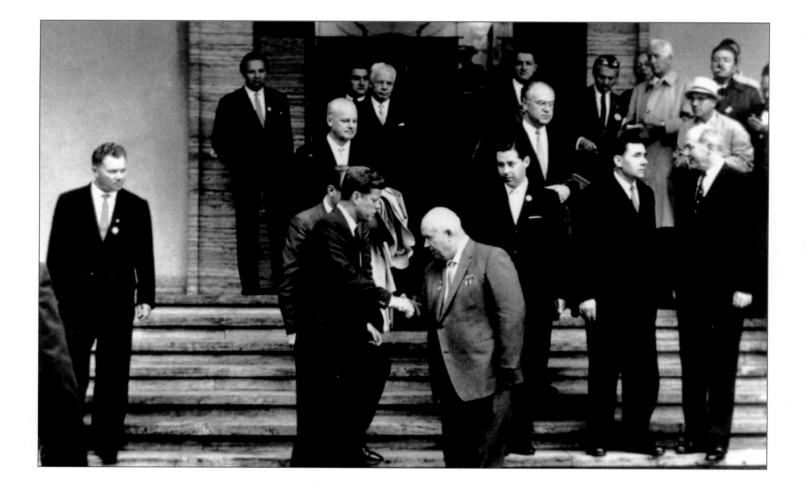

★ ★ ★ CRISIS IN BERLIN

THE VIENNA SUMMIT MEETING

The opportunity for a summit meeting with Nikita Khrushchev had first been discussed in February 1961. Four months later the two leaders were shaking hands on the steps of the American embassy in Vienna. Both men had been eager for a personal visit, to size each other up and to make their positions firmly known as they embarked on several years of confrontation. Here the two men meet for the first time.

A month after I started in the White House, I got a visit from Lucy Jarvis, co-producer of NBC's "The Nation's Future." She said, "Would you be willing to debate Aleksei Adzhubei on my show?" Now, Aleksei was the son-in-law of Nikita Khrushchev, married to Khrushchev's daughter Rada, and he was editor in chief of *Izvestia*, the most important Communist newspaper in the Soviet Union at that time. I said, "Yes," thinking to myself, "This will never happen; this man will never do this with me." About three or four months later President Kennedy went to Vienna for his first meeting with Khrushchev. When I arrived at the airport as part of the president's entourage, Ms. Jarvis was standing at the bottom of the stairs of the plane. She said to me, "You've got to come with me right away. You're going to meet Mikhail Kharlamov."

I said, "Who's Mikhail Kharlamov?"

"He's the press secretary for Khrushchev."

I went to meet Kharlamov, and he said to me, "We've heard about the possibility of this debate, and Adzhubei and I will be glad to do it." So I said, "Great." Of course, I had to get a second person to debate with me. I asked Harrison Salisbury, the top correspondent on Russia for *The New York Times.*

The debate was a sidelight to the business at hand, which was the first and only face-to-face meeting between John Kennedy and Nikita Khrushchev. But the

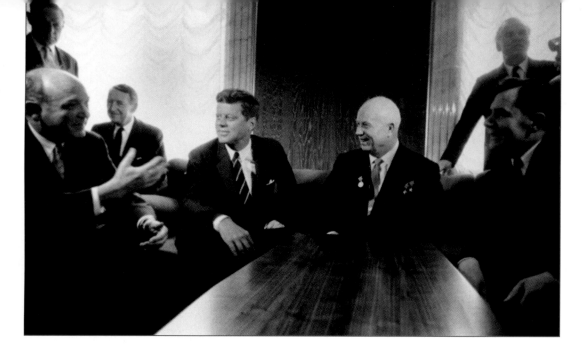

The two "teams" line up for their exchange of ideas around a coffee table in the American embassy music room on June 3. To the left, President Kennedy, Secretary of State Dean Rusk, and Ambassador to the Soviet Union Llewellyn Thompson (background, seated) advance the ideology of democracy and capitalism as best they can in the few brief stoppages of cant coming from Khrushchev and his foreign minister, Andrei Gromyko, on the right.

relationship and interplay among Adzhubei, Kharlamov, a third Russian, Georgi Bolshakov, the editor of the Soviet magazine, *USSR*, and me would have serious implications for U.S.–Soviet relations, which I was soon to find out.

The Vienna summit, on June 3 and 4 of 1961, was less a summit than a get-acquainted meeting for the leaders of the world's superpowers. But Khrushchev had sensed that the time was right to intimidate the new, young American president, who had suffered a setback just six weeks earlier at the Bay of Pigs. To Khrushchev, it seemed like a good time to dictate policy to JFK, especially on the question of Berlin. To Kennedy, however, the sole purpose of the meeting was to size up Khrushchev, not to score points or even advance the peace process significantly. He said, "I would rather meet him the first time at the summit, not the brink."

Over two days the leaders talked on a wide range of subjects, first at the American embassy, then at the Russian. The subject of Berlin came up in a serious way on the afternoon of the second day. Khrushchev, in a foul mood even after a grand meal, announced that he would be signing a separate peace treaty with East Germany in December, signifying that the Soviet Union would not officially recognize any American rights in West Berlin. Knowing full well how serious and threatening this would be to the western powers, Khrushchev stuck his chin out. If the United States wanted to go to war over it, he said, "that is your problem."

Kennedy said in response, "It is you, not I, who wants to force a change." The Soviet leader's shrug let Kennedy know that his mind was made up. The last thing Kennedy said to him was, "It's going to be a cold winter."

Re: Vienna summit

During the first meeting with Kennedy in 1961 in Vienna, Khrushchev's first proposal was to sign a peace treaty with Germany and make Berlin a free city. That was his plan at the time. It was known that before, when Khrushchev had his meeting with Eisenhower at Camp David, they were very close on some issues. I was told by a Soviet comrade that the two men were near to realizing a solution to the Berlin question. I couldn't believe it, because our information was quite different. But looking back, it may have been so. That's why Khrushchev was surprised by Kennedy's hard position against this Berlin proposal.

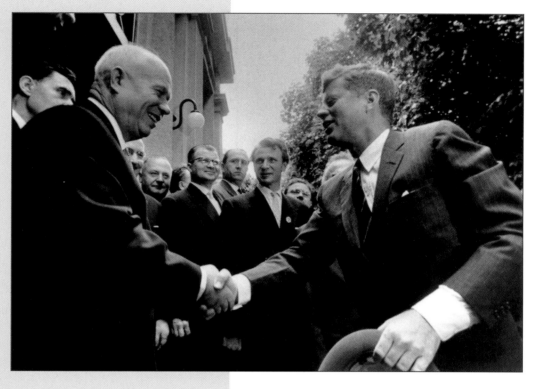

Kennedy and Khrushchev meet the next day, Sunday, June 4, at the Soviet embassy. The president had underestimated the rhetorical skills of the Soviet leader the previous day and was determined not to be put on the defensive again.

When Kennedy and Khrushchev had their meeting in Vienna, neither knew what the other's policies would be. My knowledge of this came later, but I learned that some of Khrushchev's advisers had told him that Kennedy was a weak man, that he was unsure of himself as a result of the adventure against Cuba at the Bay of Pigs and the Soviet success with the first man in space, Yuri Gagarin. These were hard shocks for Kennedy. He was a young man with not much experience as a politician. And Khrushchev planned to use this against him.

Later, it was of great importance that these two men met. In the crisis of West Berlin, Kennedy showed himself to be a man of will. Khrushchev, too, was a man of will, but he was not so well educated. He was a man of the old guard, from the Soviet leadership of the Stalin era. The confrontation in Vienna was of great importance for future crisis situations, especially in 1962 during the Cuban Missile Crisis.

—Marcus Wolf

and our Strategic Air Command bombers would be placed on instant alert. His words were forceful and clear. "If war begins, it will have begun in Moscow and not Berlin. For the choice of peace or war is largely theirs, not ours. It is the Soviets who have stirred up this crisis. We cannot and will not permit the Communists to drive us out of Berlin, either gradually or by force."

The president's mobilization move was calculated to prevent a reckless action by Moscow. The gist of Kennedy's speech reached Khrushchev when he was in disarmament session with our negotiator, John McCloy. McCloy reported later that Khrushchev went into a rage and ended their discussions immediately.

THE BERLIN WALL IS BUILT

On August 17 we saw what resulted from the U.S. mobilizations. After fortifying all the crossing points in Berlin, East German troops began building the infamous wall. Our uncertainty about whether this action was provocative and sinister kept us from making a fast countermove, although there were plenty of calls from both the

The wall was not a unified piece of construction, having been erected over time with a wide variety of materials; nor was it uniform in height or width. The construction quality was poor, but it did not have to be good. Uniformed East German guards with automatic weapons and the authority to use them were the real deterrent.

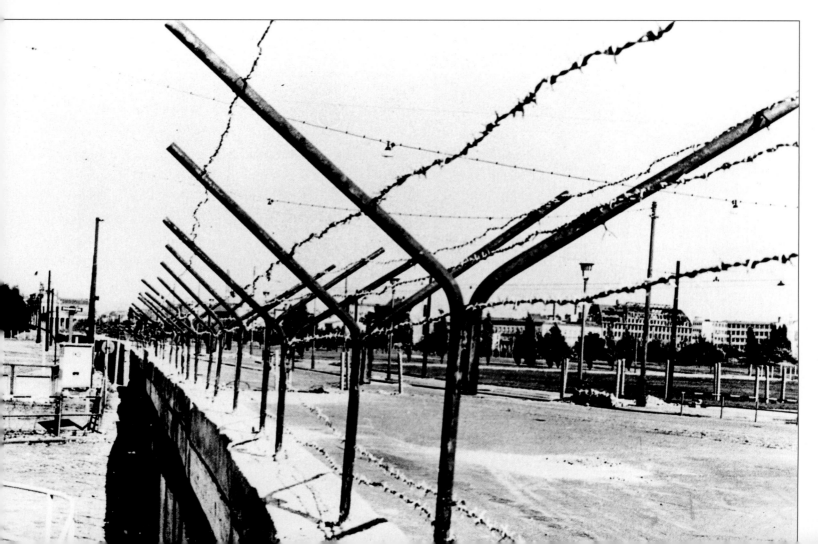

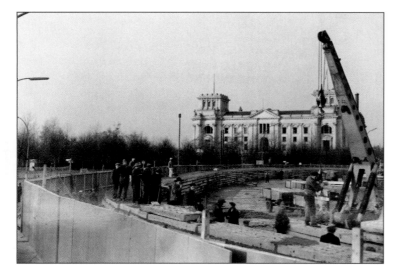

It took several months to construct the Berlin Wall in its entirety. Here East German workers continue construction begun in August 1961. The work neared the famous Brandenburg Gate in November.

Re: Berlin crisis

The events of October 1961, when Mr. [Allen] Lightner [the U.S. minister in Berlin] tried to pass the border, and the GDR at the border post tried to control him, then brought in military police, then the military itself with tanks, showed how thin the line was between peace and war, especially in Berlin. But nobody—maybe only General Clay and some in his circle—thought that there could be a serious military conflict which could lead to a big war because of the momentary actions of one official. My department was mobilized to do information gathering, but before we could get a lot of intelligence in, the crisis was over and finished.

Only later were we to learn that there was a strong order from Washington, from President Kennedy himself, that his troops were not to force this crisis. General Clay was in Berlin for several months, then was called back. When he left, we felt the crisis was finished.

I felt, though, that in this special situation, with the biggest military forces from both alliances very near and confronted on one border, there could never be a small military crisis in Berlin. Any small conflict contained the danger of becoming a big war.

—**Marcus Wolf**

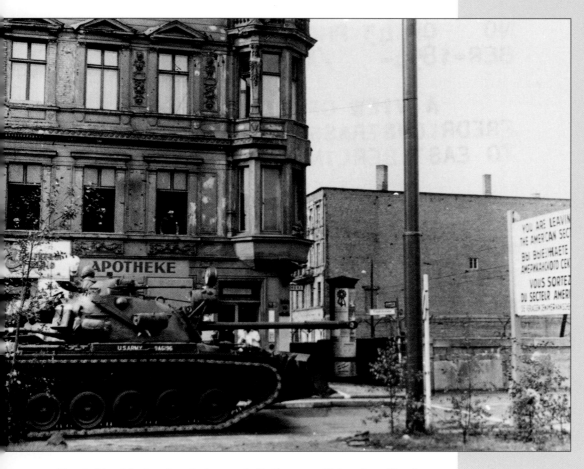

The alert level for American tank crews in Berlin was as high as it could go in August 1961. The tanks lowered their barrels and pointed them east, in the direction of the anticipated Soviet attack. The eyes and ears of ground-level tanks are aided by American servicemen, who watch for Soviet and East German tank activity from second-floor windows.

The Berlin crisis in full bloom, the president sent this comprehensive memo to Rusk and McNamara.

TOP SECRET

National Security Action Memorandum No. 92

September 8, 1961

To: Secretary of State, Secretary of Defense

1. What will the presence in Europe of six additional U.S. divisions accomplish

a. In meeting the Berlin situation?

b. In vitalizing NATO and strengthening the long-term defense of Western Europe?

2. Will an increase of our conventional forces in Europe convince Khrushchev of our readiness to fight to a finish for West Berlin or will it have the opposite effect? What other steps of all kinds may help to carry conviction on this point?

3. Supposing that we and our allies raise the ground strength of NATO to thirty effective divisions, what have we accomplished?

Specifically:

a. Can NATO then defend Western Europe against a massive conventional attack by the Soviet Bloc?

b. Can we safely mount a corps-size probe to re-open access to Berlin and at the same time present an adequate ground shield?

c. How long can thirty divisions be supported logistically in combat?

4. It has been my understanding that we would need to call additional divisions only as we actually de-cided to send existing divisions to Europe. Since our current plan is to send only one such division, why is it necessary now to call four divisions from the Reserve?

5. If we call up four additional National Guard divisions now and do not send them to Europe, how can they be usefully employed? How long would it take to convert them to Army of the U.S. Divisions? How long would it take to create effective A.U.S. Divisions by other means?

6. How much of the four division build-up would be justified in view of the overall world situation if Berlin were not an immediate issue?

7. What tactical air support is needed for the planned forces in Europe and what is the plan for provid-ing such support?

8. The reduction in terms of days of combat of the supply back-up of U.S. forces in Europe which will result from increasing our forces and from supplying the West Germans has been noted. Would this re-sult in putting U.S. troops in a possible combat situation without adequate supplies?

9. If we add six divisions to NATO, may not Khrushchev add six or more divisions to the conventional forces facing NATO? Or will logistical problems, fear of attack by atomic weapons, and preoccupations in the satellites set a limit on the Soviet conventional forces available for immediate use against NATO?

10. What is the estimated net gold cost per year of the movement of six divisions to Europe and what can be done to reduce it?

/s/ John F. Kennedy

civilian and military sectors to bulldoze the wall and dare the East Germans to stop us. While the president rejected that idea, he reinforced Berlin with 1,500 more troops and dispatched Vice President Lyndon Johnson to Berlin to reassure its citizens that we were standing with them.

That weekend, there were many people at the White House who feared that a shooting war was about to erupt. The 1,500 reinforcements heading for Berlin would have to cross East German checkpoints to get into the city. If there was resistance to their passage, World War III might be starting in the middle of the Autobahn. But, riding in armored cars, prepared for the worst, the troops encountered no problems. We all breathed a sigh of relief.

Our president had privately assessed our chances of going to war over Berlin at one in five. He had come back from Vienna with a good feel for what Khrushchev would and would not do. He did not believe the Soviet leader was as volatile in private as he appeared in public. He saw some caution in the man and believed that, despite his rhetoric, he would be the first to step back from the nuclear brink. In Berlin, on that August weekend, he was right.

But a few days later, on September 1, the president was shocked and disappointed to learn that the Soviets had broken the three-year moratorium on nuclear testing with a high-yield atmospheric blast. It was a symbolic action, saber-rattling to a high degree. It also was a personal message to Kennedy that all bets were off, since Khrushchev had told Kennedy in Vienna, "We will never be the first to break the moratorium."

BACK-CHANNEL DIPLOMACY

The whole world was now anxious about a nuclear showdown between the superpowers, and the situation in Berlin, with defectors being shot as they crossed the wall, was the trigger area. All eyes were on John Kennedy as he was set to deliver the keynote address at the U.N. General Assembly on September 22. He would be confronting the Berlin issue, and his words would let the world know whether the nuclear nightmare was approaching or receding.

In the midst of this tension, on the night the president arrived in Manhattan with his entourage, including me, Georgi Bolshakov called me. I have been told since then that Georgi was a KGB agent. A nice fellow, but an agent nonetheless. Bolshakov told

me it was most important that I meet as soon as possible with my old debate opponent, Kharlamov. We set up a semisecret meeting at my hotel the following evening.

Upon arrival, Kharlamov wasted no time. "The storm in Berlin is over," he said. With words tumbling out quickly, faster than Bolshakov could interpret, Kharlamov gave me a message that I was supposed to deliver directly to the president. The message was urgent: Khrushchev was now ready to consider U.S. proposals for defusing the crisis in Berlin. The danger there could not be left unmitigated for much longer, he said, and Khrushchev was under pressure by other Communist-bloc countries to recognize East Germany. A summit was needed, he said, and, by the way, Khrushchev would like it if President Kennedy's upcoming United Nations speech did not contain any inflammatory language or "ultimatums."

After they left, I placed a call to the president, and he called me to his hotel room at 1:00 A.M. For half an hour I repeated the key points of the message from Khrushchev to him. He gazed at the skyline of Manhattan while he listened. Then he said, "There's only one way you can read it. If Khrushchev is ready to listen to our views on Germany, he's not going to recognize the [Walter] Ulbricht [East German] regime—not this year at least—and that's good news."

He called Dean Rusk at 1:30 A.M. It was agreed the president should reply to Khrushchev's message in the same way Khrushchev had approached him. That is, through me. As I sat on the bed, the president dictated a letter. I was to read it to Kharlamov the next morning. The letter was cautiously optimistic in tone. He asked for a demonstration of good faith. If the Kremlin were willing to honor its commitments for neutrality in Laos, for example, the United States would consider a Berlin summit to be a useful undertaking. I finished writing at 3:00 A.M.

The next day, moments before he left for his U.N. speech, the president gave his approval to the final draft of the letter I was to read to Kharlamov. Thirty minutes later I had read it to Kharlamov, and presumably it was on its way to Khrushchev.

The U.N. Keynote Address

In the meantime, not one word of Kennedy's U.N. speech had been changed. In the historic chambers, on that historic day, the president delivered a great speech. It was firm but conciliatory. His main topic was disarmament, but he had this to say about

Berlin: "It is absurd to allege that we are threatening a war merely to prevent the Soviet Union and East Germany from signing a so-called 'treaty' of peace. The Western Allies are not concerned with any paper arrangement the Soviets may wish to make with a regime of their own creation, on territory occupied by their own troops and governed by their own agents. . . . If there is a dangerous crisis in Berlin—and there is—it is because of threats against the vital interests and the deep commitments of the Western Powers, and the freedom of West Berlin. We cannot fail these commitments." Apropos of the recent communication, he added, "The possibilities of negotiation are now being explored, [and] if those who created this crisis desire peace, there will be peace and freedom in Berlin."

Shortly thereafter the president and his family took a vacation in Newport, Rhode Island. I was staying nearby at the Newport Naval Station. My phone rang one evening; it was Georgi Bolshakov, calling from New York, where he was attending the meetings between Dean Rusk and Andrei Gromyko. Bolshakov said it was urgent that he see me immediately. He would fly to Newport right away, if necessary. We did not want him to be seen in Newport, so I arranged to go to New York the next day. Bolshakov was irritated. "If you knew what I had," he said, "you wouldn't keep me waiting that long."

As President Kennedy addressed the United Nations on September 25, 1961, the Soviet delegation paid particular attention. Georgi Bolshakov had earlier conveyed both a message and a request to the president from Khrushchev; the premier wanted to end the Berlin crisis, and would the president please not say anything provocative in his U.N. speech? Left to right: Andrei Gromyko, minister of foreign affairs; Valerian Zorin, deputy minister of foreign affairs; V. S. Semenov, deputy minister of foreign affairs; and S. G. Lapin. The president's message never had been inflammatory, so there was no need to modify it for Khrushchev's benefit. But it was firm in its reaffirmation of America's commitment to Berlin and Vietnam.

At the appointed time Bolshakov was at my door with two folded newspapers under his arm. From between them he pulled out a thick manila envelope, saying, "Here, you may read this. Then it is for the eyes of the president only."

I read it. It was a twenty-six-page personal letter from Nikita Khrushchev to Kennedy. In it the Soviet leader said that he saw no reason why negotiations could not produce settlements in both Laos and Berlin. He was willing to take a fresh look at all Soviet positions that the West found objectionable. It was a candid, heartfelt, and therefore hopeful overture.

It was the first of what became a two-year personal and secret correspondence between the two leaders, perhaps unique in modern diplomacy. And at that moment

Khrushchev's old nemesis, General Lucius Clay, was introduced to the assembled troops of the Berlin Brigade by the president at a June 27, 1963, ceremony in Berlin. On the platform with them were Brig. General Hartel, U.S. Ambassador to West Germany George McGhee, and Maj. General James Polk, U.S. commandant in Berlin.

only four men in the world knew about it—Khrushchev, Gromyko, Bolshakov, and I.

Bolshakov enjoyed my surprise on reading the letter, but soon he was gone. I had the president on the phone before Bolshakov was out of the building. He told me to get the letter to Dean Rusk as soon as possible, then to bring it up to him in Newport.

Kennedy and Rusk agreed to respond to the letter promptly, in a corresponding manner, which meant that Bolshakov and I would be doing secret courier work again and again. Khrushchev would always write first. I would get a call from Bolshakov saying there was "a matter of urgency." We would meet on the street, or in a bar, and the envelope would be exchanged. If I were not available, Bobby Kennedy or Ted Sorensen would meet with Bolshakov. This system of communication lasted until Kennedy's death, and it served both sides well as a pressure-relief valve, out of sight of the media, the diplomatic community, and the public.

Those letters now reside in the Kennedy Library and will be released at the library's discretion. A reading of all of them will reveal Khrushchev's two obsessions—agriculture and Berlin. Berlin, in fact, was Khrushchev's key to peaceful coexistence. If resolution could be worked out there, other agreements would happen quickly.

MEETING WITH KHRUSHCHEV

When I met with Khrushchev over a long day at his *dacha* (the details of which are recounted in my book *P.S. A Memoir*), the only topic that roused his anger all day was Berlin. I had reiterated the president's policy that the United States would not use nuclear weapons first unless we were facing mass Communist aggression. To that Khrushchev said he would apply exactly the same policy to the defense of East Germany. If Western troops crossed its borders, he said, he would initiate a nuclear attack. He shook his finger in my face. "And I am talking facts, my friend, not theory."

Re: Berlin crisis

If the road from West Germany to West Berlin had been closed by steps taken on our side, there existed a NATO plan, the so-called Live Oak plan. It was very secret, but we had it. This plan outlined the steps that every U.S. military and allied group was to take if U.S. troops were stopped on the Autobahn—to break through, and ultimately, to authorize selective atomic strikes. I cannot be sure, but I felt that knowledge of this plan helped Moscow to prevent steps which could lead to a serious military conflict.

—Marcus Wolf

But his anger dissipated quickly, and next he said, "I am now going to tell you an official state secret." He spoke of that day in August 1961 when American and Soviet tanks had faced each other on opposite sides of the Brandenburg Gate. He blamed the whole thing on General Lucius B. Clay, saying, "Clay is as much a general as I am a shoemaker!" General Clay was the commander of the Berlin Brigade, the American forces in West Berlin. Clay had been commandant of the American sector of Berlin in 1948, during the period known as the Berlin Airlift. Khrushchev went on to say that he ordered Marshal Rodion Malinovsky, Soviet minister of defense, to reposition his vehicles. "West Berlin means nothing to us, so I told Malinovsky to back up our tanks a little bit and hide them behind buildings where the Americans couldn't see them. If we can do this, I said to Malinovsky, the American tanks will also move back within twenty minutes and we will have no more crisis." He grinned. "It was just as I said it would be. We pulled back. You pulled back. Now that's generalship!"

He also told me this: "I personally ordered the construction of the wall. A state is a state and must control its own borders."

Near the end of my visit he made a final point. "West Berlin is an important test—it is a Rubicon. If we cross it without war, all will go well. If not, it will be too bad."

Despite continuing negotiations, the Berlin situation never improved while John Kennedy was alive. He visited the wall on his European trip on June 26, 1963, seeing it from Checkpoint Charlie.

In 1989, when the wall finally came down without a shot fired, I could not help thinking back to those nervous days and months of late summer 1961, when the world's two tough guys met on a street corner in Berlin, almost came to blows, but backed off before momentum carried them, and all of us, into global war.

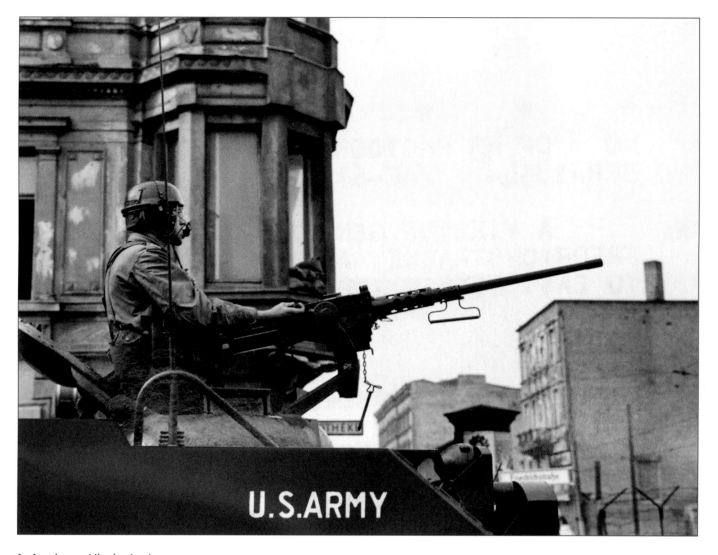

An American soldier is clearly
ready to pull back the bolt on his
.50-caliber machine gun at the
slightest provocation from the
east. But a fire order would have
to come from an officer, probably
positioned on a rooftop, before
real shooting could begin.

A Soviet staff car negotiates its way between two
American tanks as it enters the American sector
at Checkpoint Charlie. Significantly, the tanks
are fitted with bulldozer-type front blades,
designed to help knock down the wall if an
advance to the east were ordered.

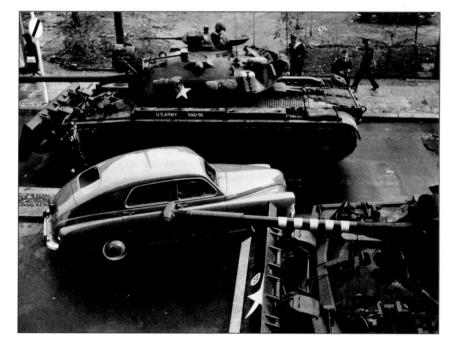

A line of American M-48 main battle tanks take their positions along the Berlin Wall, facing the Soviet sector to the east. In military terms this was a show of strength and resolve but not an intimidating force. Military strategists knew they would be no match for the sheer numbers of Soviet tanks that could be brought up quickly on the other side. But what kept the situation stabilized was the clear signal from President Kennedy to Khrushchev that an attack on West Berlin would be considered as provocative as an attack on an American city and would justify a nuclear exchange with the Soviet Union.

U.S. tanks of Company F, Fortieth Armor, Berlin Brigade, stand with barrels down at the Friedrichstrasse checkpoint in October 1961.

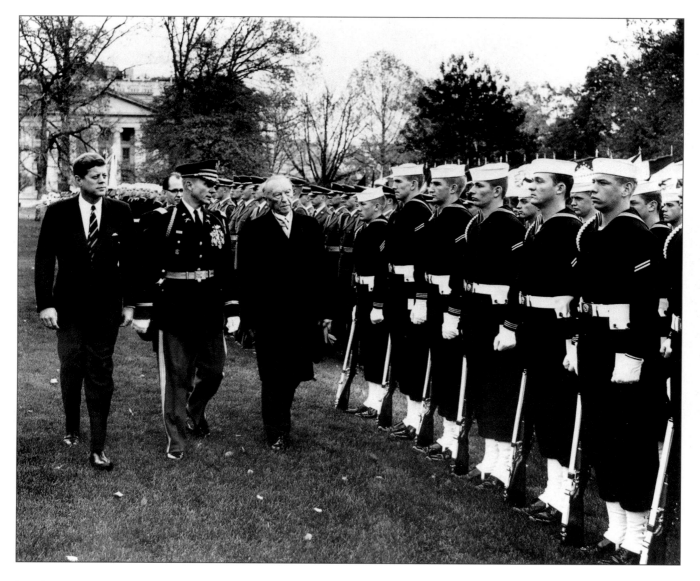

West German Chancellor Konrad Adenauer visited the president in Washington, November 22, 1961. The Berlin situation made Kennedy and Adenauer close allies by necessity, but there was a certain amount of tension between them, especially on Berlin policy matters. As a politician of the old school, Adenauer took a hard line with the Soviets, which clashed occasionally with Kennedy's approach and caused Khrushchev to characterize Adenauer as "a dangerous and senile old man." Adenauer was also initially concerned that Kennedy's friendship with Willy Brandt, an Adenauer political opponent, would complicate their relationship.

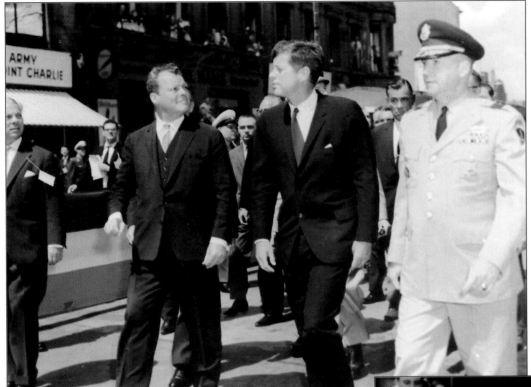

The president's entourage arrives at Check-
point Charlie. With Kennedy were West Berlin
Mayor Willy Brandt and Brig. General Hartel.

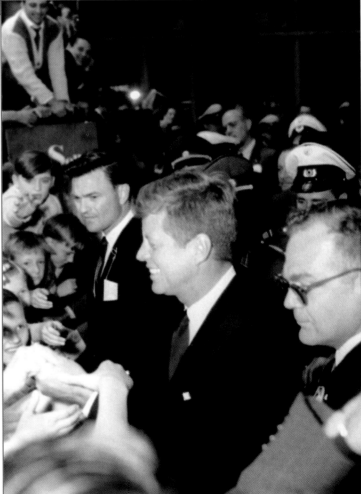

The late-June 1963 European trip that took Kennedy to Germany,
Ireland, England, and Italy was designed to strengthen U.S. ties
to those countries. The crowds that turned out for the president
and Mrs. Kennedy numbered in the millions, and their adoration
of the couple was overwhelming. Kennedy landed first in Bonn,
and the crowds that welcomed him in the German capital were
large and wildly enthusiastic. He addressed a huge crowd,
saying that America was "here on the continent to stay so long
as our presence is desired and required." Kennedy greets a
crowd of West Germans. Some waited for hours to get just a
glimpse of the man in whom they had so much hope.

Kennedy, Brandt, and Adenauer
ride through the streets of Berlin,
June 26, 1963.

President Kennedy meets the troops
of the Berlin Brigade at Berlin head-
quarters. With him are General Clay
and Maj. General Polk.

The president took time to visit the U.S. military base at Hanau on June 25, reviewing the massed armored vehicles of the Third Armored Division that had been sent to Germany during the crisis in West Berlin.

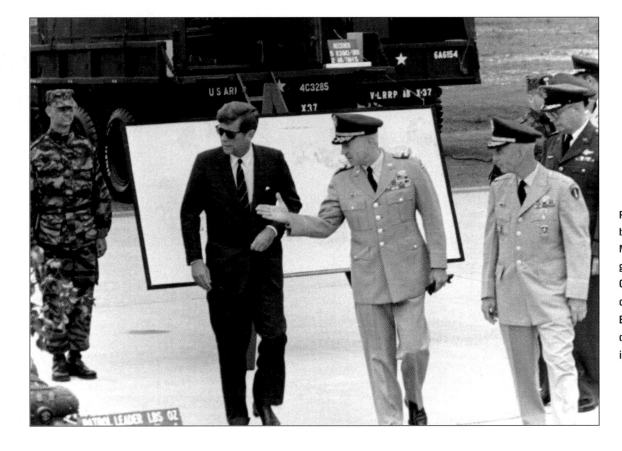

President Kennedy, escorted by Lt. General John H. Michaelis, commanding general of V Corps, and General Paul Freeman, commander of Army Reserve, Europe, reviews the static displays set up for his inspection at Hanau.

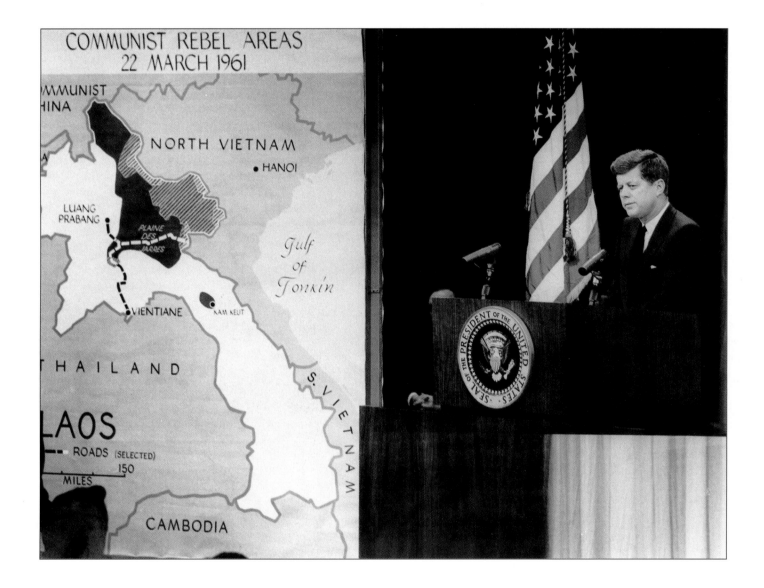

★ SOUTHEAST ASIA

The president got politically and militarily involved with Southeast Asia in the first two months of his presidency. The nationally televised press conference on this day concerned the details of the impending Communist takeover of Laos. He had decided to make a show of honoring our defense obligations in Southeast Asia, sending the Seventh Fleet and over one thousand marines to Thailand and a small advance group of marines to the Thailand–Laos border. The Soviets, he suggested, were behind this subversion of a nation whose neutrality had been agreed upon.

To his left on the stage of the auditorium of the new State Department Building were Pierre Salinger and Associate Press Secretary Andrew Hatcher. The Kennedy administration, under Salinger's leadership, placed special emphasis on the presidential press conference. Kennedy was a poised, quick-witted speaker, and did well in impromptu sessions (although he prepared thoroughly for every planned press session, and critiqued his performance when the conferences were replayed later in the evening on television).

THE BEGINNINGS OF U.S. INVOLVEMENT

The scene: a presidential press conference, April 11, 1962. "Mr. President, what are you going to do about the American soldiers getting killed in Vietnam?"

Kennedy: "Well, I am extremely concerned about American soldiers who are in a great many areas of hazard. We are attempting to help Vietnam maintain its independence and not fall under the domination of the Communists. The government has stated that it needs our assistance in doing it. It presents a very hazardous operation, in the same sense that in World War I, World War II, Korea, a good many thousands and hundreds of thousands of Americans died. But we cannot desist in Vietnam."

The war in Vietnam that overwhelmed this nation for fifteen years and nearly tore it apart was in its infancy when John Kennedy took office in 1961. The previous administration had placed about six hundred military advisers in South Vietnam to counter the military and political incursions of the National Liberation Front (the Vietcong), which sought to overthrow the government of President Ngo Dinh Diem. The U.S. actions were legitimized and limited by the terms of the Geneva Conference of 1954.

The Vietcong successes in the rural parts of Vietnam in 1959 and 1960 began destabilizing the country, and this was accelerated by an arrogant and dictatorial Diem regime that was losing contact with its people.

In addition, another Southeast Asian nation, Laos, was in turmoil. The Communist Pathet Lao were destabilizing the ceasefire between the government of the former premier, Prince Souvanna Phouma, and rebel forces, a battleground President Kennedy saw as a direct confrontation point between himself and Khrushchev, who backed the

The 1954 Geneva Accords, which the United States did not sign but tacitly followed, limited military advisers in Vietnam to just under seven hundred in number. But as the South Vietnamese army grew, so did the need for U.S. advisers. By the end of 1961, there were two thousand of them in Vietnam. American advisers, like the one this picture, tried to integrate Army of the Republic of Vietnam (ARVN) troops into U.S. military doctrine.

rebels. The president was keenly aware of the Soviet Union's stated goal of inspiring and supporting insurgencies around the globe and recognized Southeast Asia's potential as a powderkeg.

General Maxwell Taylor emerged as the person who could go to Vietnam and give the president a personal assessment of the situation. He left on that mission, at Kennedy's request, in late 1961. It was the first of many trips to Vietnam for him. When he returned, his conclusions on the correct path for the United States to take in Vietnam were passed on to the president. He made two basic observations. The first was that the South Vietnamese were capable of defeating the Vietcong. The second was that they could not do it without an escalation of U.S. aid, in the form of personnel and supplies. President Kennedy and the Joint Chiefs of Staff took Taylor's recommendations to heart and gradually increased the number of men and amount of materiel sent to Vietnam.

November 16, 1961

His Excellency
Nikita S. Khrushchev
Chairman of the Council of Ministers of the
Union of Soviet Socialist Republics

Dear Mr. Chairman:

I have now had a chance to study your most recent two letters on the German problem and on Laos and Vietnam. I shall be writing you again about Germany and Berlin, but I do wish to give you my thoughts about Laos and Vietnam as soon as possible.

. . . As to the situation in Vietnam, I must tell you frankly that your analysis of the situation there and the cause of the military action which has occurred in Southern Vietnam is not accurate. Precisely because of the visit of such Americans as Vice President Johnson and General Taylor we are, as you yourself recognize, well informed as to the situation in that country. . . .

It is the firm opinion of the United States Government that Southern Vietnam is now undergoing a determined attempt from without to overthrow the existing government using for this purpose infiltration, supply of arms, propaganda, terrorization, and all the customary instrumentalities of communist activities in such circumstances, all mounted and developed from North Vietnam.

It is hardly necessary for me to draw your attention to the Geneva Accords of July 20–21, 1954. The issue, therefore, is not that of some opinion or other in regard to the government of President Ngo Dinh Diem, but rather that of a nation whose integrity and security [are] threatened by military actions, completely at variance with the obligations of the Geneva Accords.

Insofar as the United States is concerned, we view the situation in which the Republic of Vietnam finds itself with the utmost gravity and, in conformity with our pledge made at the Geneva Conference on July 21, 1954, as one seriously endangering international peace and security. Our support for the government of President Ngo Dinh Diem we regard as a serious obligation, and we will undertake such measures as the circumstances appear to warrant. . . .

I have written you frankly about Laos and Vietnam for a very simple reason. Both these countries are at a distance from our own countries and can be considered areas in which we ought to be able to find agreement. I am suggesting to you that you use every means at your disposal to insure a genuinely neutral and independent Laos . . . and to insure that those closely associated with you leave South Vietnam alone. . . .

Sincerely,

John F. Kennedy

After the Vietnam Task Force meeting of October 11, 1961, wherein the pros and cons of active U.S. military involvement were discussed, JFK decided to send Maxwell Taylor to Vietnam, along with Walt Rostow and Brig. General Lansdale. It was a desperate decision; the president did not know what else to do. More information, from a man as well thought of as Taylor, was the only thing that made sense to him. Taylor, Rostow, and Lansdale left for Vietnam on October 17. They reported back to the president on November 3. They recommended sending six thousand troops, and to be prepared to send more. "There is reason for confidence," Taylor said. But while troops needed to go in, Diem, in their opinion, had to go.

People all around the president lined up on both sides, arguing for and against increasing the U.S. role. While JFK was instinctively against sending troops, he fell in behind the argument that the United States could not let the Vietnam domino fall to the Communists. He did not agree to send the troops Taylor recommended right away, but he did increase the number of American advisers and other forms of support. The troops would go in later.

THE ROLE OF THE PRESS IN VIETNAM

By early 1962, higher troop levels and the increased number of helicopters in Vietnam were very noticeable to the press corps, who were already prickly about what they perceived as less-than-candid information coming from the military, especially from General Paul D. Harkins, U.S. military commander in Vietnam. The military establishment in Vietnam had put a tight lid on news about actual field operations, preferring to keep the press in the dark or diverting their attention toward less sensitive news. This news blackout antagonized the Vietnam-based press, which scratched and clawed for the real stories, and often found them. To head off a major conflict with the press, I told the president that I felt the press policy needed to be changed to allow more access to people and operations. The president agreed, and after some personnel and policy changes, we felt the situation had been "liberalized" to an acceptable extent.

The effect of the Vietnam-based press's newfound access to information about various military activities was damaging beyond belief. Stories emerged of a military

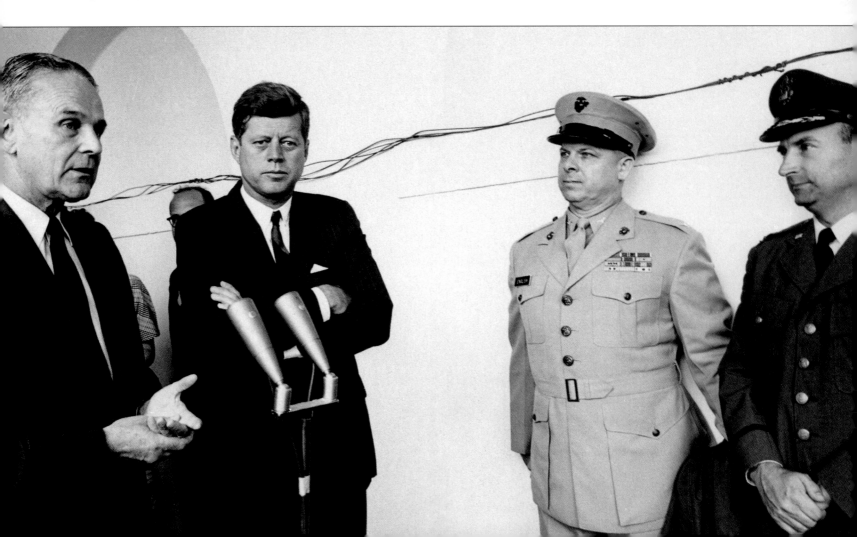

TOP SECRET

November 22, 1961
National Security Action Memorandum No. 111
To: The Secretary of State
Subject: First Phase of Viet-Nam Program

A more aggressive policy in Vietnam led to the initiation of jungle defoliation programs in early 1962, and these created the impression that the momentum was shifting in America's favor. A top-level change was a positive symbol, too, and General Paul Harkins was put in charge of the new U.S. Military Assistance Command Vietnam by the president. General Harkins was a Maxwell Taylor choice. He made it a point to put the best possible face on sketchy ARVN performance in 1962. Here the general inspects a U.S.-run antiguerrilla training camp.

The President has authorized the Secretary of State to instruct our Ambassador to Viet-Nam to inform President Diem as follows:

1. The U.S. Government is prepared to join the Viet-Nam Government in a sharply increased joint effort to avoid a further deterioration in the situation in South Viet-Nam.

2. This joint effort requires undertakings by both Governments as outlined below:

a. On its part the U.S. would immediately undertake the following actions . . .

(1) Provide increased air lift to the GVN forces, including helicopters, light aviation, and transport aircraft, manned to the extent necessary by United States uniformed personnel . . .

(2) Provide such additional equipment and uniformed personnel as may be necessary for air reconnaissance, photography, instruction in and execution of airground support techniques, and for special intelligence.

(3) Provide the GVN with small craft, including such United States uniformed advisors and operating personnel as may be necessary for operations in effecting surveillance and control over coastal waters and inland waterways.

(4) Provide expedited training and equipping of the civil guard . . .

(5) Provide such personnel and equipment as may be necessary to improve the military-political intelligence system . . .

(6) Provide such new terms of reference, reorganization and additional personnel for United States military forces as are required for increased United States military assistance in the operational collaboration with the GVN and operational direction of U.S. forces . . .

McGeorge Bundy

Hundreds of Military Assistance Advisory Group (MAAG) advisers were working with ARVN regulars on counterinsurgency programs. Here an American adviser listens to his translator before starting a mission out of Vinh Long airstrip. Although the advisers were understood by the American public to have training status, in reality they were often leading offensive combat maneuvers and fighting alongside ARVN troops.

situation that was at odds with the official description: of U.S. soldiers' involvement in combat operations, of U.S. helicopters being shot down in firefights, of deaths of American soldiers. Against the context of our officially stated role in Vietnam—training and support *only*—the reports were sensational, and for the first time they raised the possibility to the American people that this small support mission could turn into a "real" war and might even be one at the moment.

The president was stung by some of these stories. I believe he felt he was being mischaracterized by the press as being devious about our intentions. Following the Bay of Pigs, and still mired in the Berlin crisis, the president was sensitive to the backlash that would attend the perception that the United States was involved in another military situation. So he strongly recommended that the new rules on press freedom be curtailed, especially as regards field operations. I believe he, and others in the administration, truly felt that the increased involvement of the United States was not an "escalation," and he certainly did not see our involvement, as the press did, as a cause for alarm.

The basic confrontational dynamic between the American government and the news media regarding Vietnam was thus set, and it remained in place for fifteen years. The government was always trying to downplay its role in the war, and the media were always trying to expose it.

President Kennedy's plan to meet the challenge of the Soviet Union's global insurgency plan called for new techniques and new training. At Fort Bragg, North Carolina, the John F. Kennedy Center for Special Warfare was created. One part of the center, called the James Gabriel Demonstration Area, featured a mock Vietnamese village, in which American soldiers participated in realistic combat operations. Specially trained U.S. soldiers played the part of Vietcong guerrillas and used techniques and tactics learned from actual combat in Vietnam to introduce green troops into the realities of unconventional warfare. Here two "Vietcong" plan a surprise attack on the village.

A Special Forces sergeant examines a punji trap, typical of the hazards of Vietnam combat. Unsuspecting American and ARVN soldiers would fall into these man-sized pits, obscured by jungle foliage, and be speared, often fatally, by sharpened bamboo stakes.

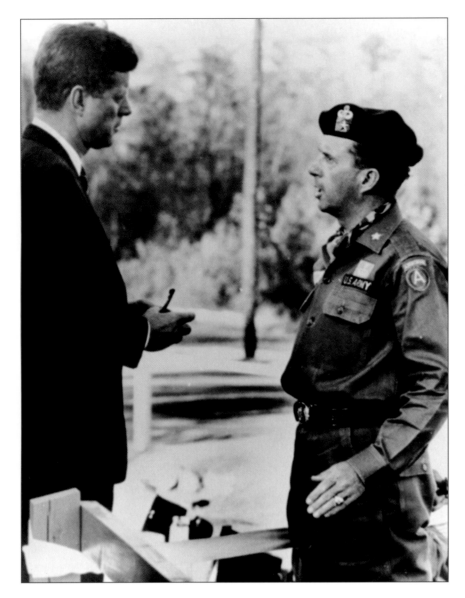

President Kennedy talks with Brig. General William P. Yarborough, commander of the Special Warfare Center at Fort Bragg. Yarborough was a Green Beret and among the first to wear the distinctive headgear of the Special Forces.

THE PRESIDENT'S INTEREST IN MODERN WARFARE

In many ways John Kennedy's presidency concerned itself with the nature of modern warfare. The previous commander in chief, President Eisenhower, had led the Allied armies to victory in World War II in the conventional style—massed troops combined with vast fleets of warships and hundreds of thousands of airplanes. The world President Kennedy faced was different in two respects. First, the specter of nuclear missiles lurked behind every action and exercise of American foreign policy. Second, the Soviet Union had declared itself to be an active supporter of "wars of liberation," which President Kennedy correctly took to mean that the Soviets would be encouraging small shooting wars in every corner of the globe. Conflicts such as in Vietnam demanded a U.S. response lest another government be overrun by Communist arms. These factors created a tightrope on which American military policy had to walk—on the left, nuclear war; on the right, widespread "localized" wars. In no global situation was the conventional massed-army approach of World War II applicable in 1961.

But our military apparatus was still configured to fight World War II–style wars, and President Kennedy was ahead of his time in seeing that that configuration had to change. The jungle of South Vietnam was the perfect place to employ what Kennedy believed was the proper military tactic of the 1960s: small, highly mobile units of counterguerrilla specialists who could deploy rapidly to any trouble spot on earth.

When John Kennedy was wearing his commander in chief hat, he was very involved in the details of restructuring American forces, from the tactics and training of the Special Forces (who became known as Green Berets because Kennedy wanted them to have an esprit and an identity, and insisted they wear distinctive headgear) to the development of the M-16 rifle.

One of his first presidential directives as commander in chief, sent out to the secretary of defense over McGeorge Bundy's signature on February 3, 1961, just weeks after the inauguration, read:

At the National Security Council meeting on Feb. 1, 1961, the President requested that the Secretary of Defense, in consultation with other interested agencies, should examine means for placing more emphasis on the development of counterguerrilla forces. Accordingly, it is requested that the Department of Defense take action on this request and inform this office promptly of the measures which it proposes to take.

After Kennedy's meeting with the Joint Chiefs three weeks later, the summary memo from the chiefs contained these entries:

Essential points arising from JCS meeting with the President on Thursday, February 23, 1961.

1. The President wishes to have the maximum number of men trained for counter-guerrilla operations put into the areas of immediate concern.
2. He wishes to have the matter of operations in Vietminh territory pressed.
3. The JCS ought to review policy guidance on Latin America and orient it towards a deterrence of guerrilla operations and counter-guerrilla operations.
4. The Departments of State and Defense ought to consider new instructions to the relevant ambassadors on the urgency of counter-guerrilla operations.
5. The JCS should insure that the MAAGs (Military Assistance Advisory Groups) are orienting their work in the relevant areas towards counter-guerrilla operations, using maximum influence on the local military.

By the end of June 1961, the president was more emphatic about developing "future requirements" for military use, as this National Security Action Memorandum of June 28 records:

Subject: Evaluation of paramilitary requirements

The President has approved the following paragraph: "It is important that we anticipate now our possible future requirements in the field of unconventional warfare and paramilitary operations. A first step would be to inventory the paramilitary assets we have in the United States Armed Forces, consider various areas in the world where the implementation of our policy may require indigenous paramilitary forces, and thus arrive at a determination of the goals which we should set in this field. Having determined the assets and the possible requirements, it would then become a matter of developing a plan to meet the deficit."

The President requests that the Secretary of Defense in coordination with the Department of State and the CIA make such an estimate of requirements and recommend ways and means to meet these requirements.

—McGeorge Bundy

July 15, 1963

Memorandum for Secretary McNamara

I was tremendously impressed with the Special Forces Unit in West Germany. However, I am wondering if we are making the best use of this Unit? Wouldn't it be a good idea to send them on training missions through the Latin American countries, Africa, Asia, or the Middle East? They could go in groups of various sizes. It seems to me a wasted effort to keep them as a single unit in West Germany where the prospects of guerrilla action are very slight. Should we tie up approximately 1,000 of our best men on what amounts to garrison duty when they could be demonstrating and training all over the underdeveloped world where the guerrilla actions are rising in intensity?

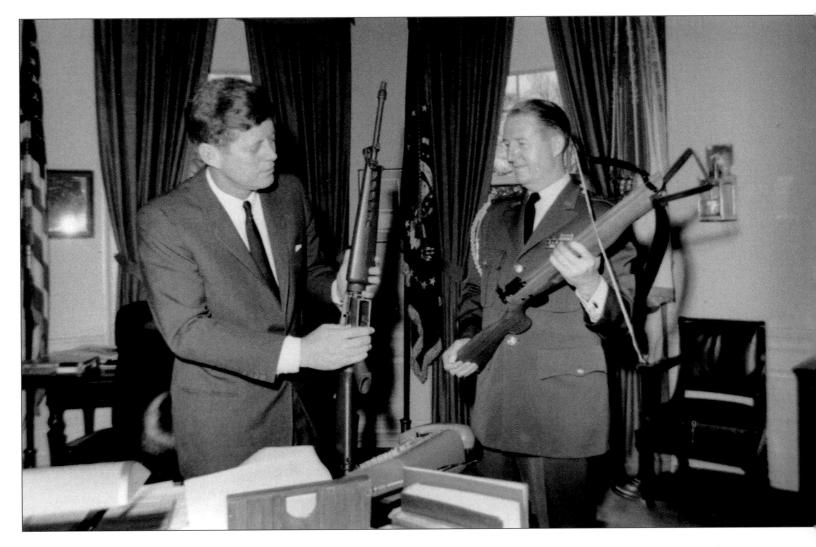

In April 1963, Maj. General Chester V. Clifton brought two weapons into the Oval Office for examination by the president. Clifton carries a shoulder-fired crossbow, designed for use as a silent weapon in counterguerrilla operations, such as in Vietnam. Kennedy hefts an M-16 rifle. It did not escape the president's attention that the standard arms designed for use by American soldiers, such as the M-16, were much too large and heavy for effective use by Laotian or South Vietnamese soldiers. The rifle butts, he judged, would have to be under their armpits to reach the trigger. Typical of the Pentagon to be so short-sighted, he said. Kennedy asked General Clifton to draft a recommendation to the Joint Chiefs for a smaller weapon to be sent to our Asian allies.

In or Out of Vietnam?

From the perspective of the 1990s it is easy to see the beginning of what became America's serious involvement in Vietnam in these escalations. Ironically, at least twice the president had been given the advice, from men he respected, to stay out of Vietnam. The first came in a two-hour meeting with General Douglas MacArthur, who had come to visit Kennedy in the Oval Office. I was not a party to their conversation, but General MacArthur came out and talked to me for a while. He had strongly advised the president never to send troops into Vietnam. He said, in essence, that if you do, it will be a disaster, because the war over there is going to be totally different from any war we have been involved in before. They've got guerrilla experts. America is not set for that kind of war, we'll not win that war, and we will lose a lot of people. It seemed to me that MacArthur, at that particular point, had totally convinced Kennedy that he should not get into a full-time war in Southeast Asia.

The other advice came in talks with Charles de Gaulle. The French leader and Kennedy had many discussions over the years about world situations, and on more than one occasion De Gaulle told the president to avoid getting in too deeply in Vietnam. Having recently departed Vietnam himself, he was in a unique position of experience on this matter. But Kennedy's desire to thwart Communist plans to take over all of Southeast Asia was, in my view, the only position he could take at that time. The limited role he called for was clearly in our national interest. He could not have foreseen the deep negative effect the war in Vietnam would have on the country in later years.

With the urging of people in the field such as Brig. General Edward Lansdale and General Harkins, and with positive outcome projections from White House advisers like Walt Rostow, the president weighed in on the side of increased involvement.

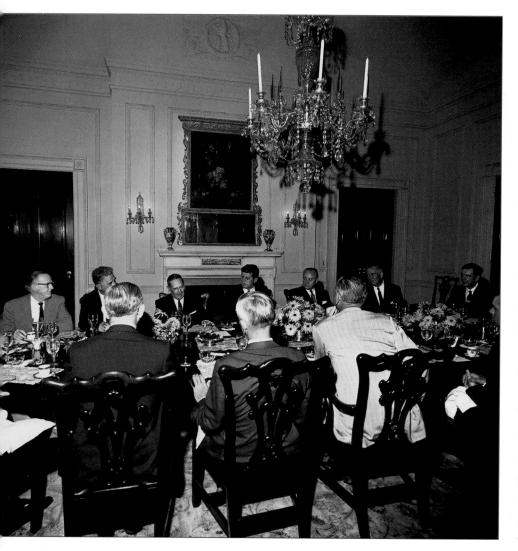

General Douglas MacArthur visited the White House and spent some time with President Kennedy in the Oval Office on July 20, 1961. MacArthur's position on U.S. involvement in Southeast Asia was already known—he had personally warned the president back in May to stay out of Laotian entanglements.

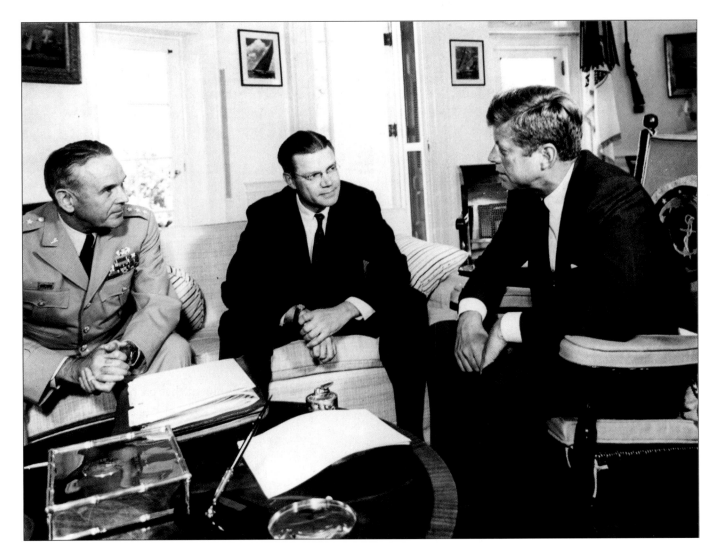

President Kennedy, Robert McNamara, and General Maxwell Taylor meet in the Cabinet Room, September 1963. The situation in Vietnam was very much on all of their minds and beginning to be on the minds of American citizens. Newspaper photographs were showing the results of napalm bombings, and the death toll of American advisers was at forty-five. The CIA, the Joint Chiefs, and Kennedy's own advisers disagreed about everything from combat status to the proper levels of American commitment.

On November 19, 1963, I went to Tokyo with six members of the cabinet, stopping in Honolulu for two days. We had a long meeting on the Vietnam issue. Diem had been killed in the coup, and since that time there was a definite feeling that the situation was changing, for the worse, rapidly. Six or seven weeks earlier Kennedy had asked me to pull the press in and announce that in January of 1964 he was going to withdraw 2,500 troops from Vietnam, beginning the reduction of the total number of troops there. It was clear that he felt the only way to handle our problems in Vietnam was through negotiations with the North Vietnamese, trying to resolve the situation with dialogue as he had done in the Cuban Missile Crisis. The agreement in the room that day in Honolulu was that the situation in Vietnam was getting dangerous—very dangerous—and we sent a message to Kennedy saying, "For the time being, you've got to cancel pulling out the 2,500 troops because the situation is getting out of hand." A few days later the president was dead.

Speculation on Kennedy's Intentions

The big question, of course, remains—would JFK have followed through with his idea of getting us out of Vietnam? I think he probably would not have gotten America involved more deeply in the war, but I cannot say that with 100 percent certainty. He could easily have followed the same path taken by Lyndon Johnson in the middle 1960s.

It is pure speculation on my part, but I do not believe John Kennedy the commander in chief would have tolerated for long the kind of military frustration our troops encountered in the mid- to late 1960s. He would have either restructured the rules of engagement to allow the United States to win the war or extracted our troops. Neither would he have tolerated the deep societal rift that the Vietnam War created in the late 1960s and early 1970s.

Several other JFK insiders have said that the president was clearly going to pull out of Vietnam once the 1964 presidential campaign had been waged and won. It has even been speculated (not by any Kennedy advisers) that this planned withdrawal, once announced, may have caused his death. We will never know about that. But I do believe that if John Kennedy had not been assassinated, there would not be a Vietnam Memorial on which are inscribed today the names of fifty thousand brave Americans killed in action in the jungles of Southeast Asia.

Kennedy never visited Vietnam as president of the United States. He did, however, visit when he was a congressman in 1951. That's him in the back right of this rare photo, which shows French General Jean de Lattre de Tassigny on the streets of Saigon.

The ARVN, backed by U.S. Army materiel and advisers in the early 1960s, gradually began to look, and act, like U.S. troops. The U.S. effort may have been modest in the beginning, but in those early days of American involvement, there was a camaraderie between U.S. advisers and the Vietnamese troops they were sent to help. In this February 1963 photo, members of the Second Battalion, Tenth Infantry, Seventh Regiment, wait to be airlifted by U.S.-supplied helicopters to the Hau My area, fifty miles south of Saigon. The squad leader mans a PRC-10, the all-purpose radio ubiquitous in Vietnamese combat situations.

The South Vietnamese Army that U.S. soldiers came to regard as ineffective, even cowardly, in the 1970s was quite the opposite in the years John Kennedy was commander in chief. U.S. Rangers and Special Forces advisers assigned to South Vietnam from 1961 to 1963 told tales of great courage, combat readiness, and skill from elite South Vietnamese units.

The creation of Vietnamese Rangers was a priority for the U.S. government and for Kennedy in particular in 1962. Semisecret training bases run by U.S. Army Rangers at places like Trung Lap started turning out South Vietnamese soldiers of exceptional ability. Many of these men belonged to the Biet Dong Quan, or Black Tiger, units, identified by their shoulder patch. They were among the few ARVN units who inspired fear in the Vietcong.

Of all the new weapons and doctrine brought to the military under President Kennedy's leadership, none was as visible or had as much impact as the helicopter, specifically the UH-1 ("Huey"), the embodiment of Kennedy's desire for air mobility. The helicopter fit perfectly with Kennedy's military thinking—that it was better to react quickly to a trouble spot than to station American troops permanently around the world.

The Huey found its niche in Vietnam. This was the workhorse vehicle of that conflict, serving as a troop transporter, firepower platform, medical evacuation ambulance, reconnaissance vehicle, and small cargo mover. This particular one sports an automatic weapon called a "chain gun," which could deliver a withering amount of fire to the ground below.

A major part of the army's new emphasis on speed, mobility, and deployability—the "flexible response," in General Maxwell Taylor's words—was the need for a new lightweight, tracked armored vehicle that could be airlifted anywhere. The armored personnel carrier M-113, shown here at a January 1961 demonstration for NATO, became that vehicle. Called a "track" by soldiers, it was the armored vehicle that fought the Vietnam War, although some conventional heavy armor saw action there, too. The M-113 could be configured in an ingenious number of ways, including a cavalry version that had armor shielding around the deck guns. It was the perfect vehicle for the type of counterguerrilla action that President Kennedy predicted would be America's steady diet in the 1960s.

A Biet Dong Quan Ranger heads to the rear without his hand, lost in a firefight. He is too proud to lie down on a stretcher.

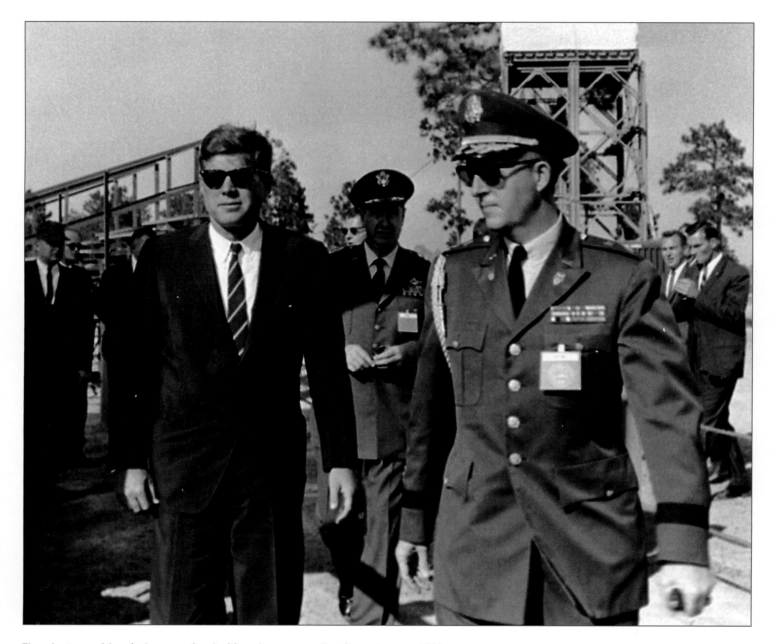

The robustness of America's conventional military forces, as well as its nuclear capabilities, were much on the president's mind in October 1961. The issue was parity—were U.S. forces equal to those of the Soviet Union? Kennedy was fairly certain that the military resources under his command were not just equal but superior to those of the Soviet Union. But a trip to Fort Bragg on October 12, 1961, was the time to confirm it. Here General Clifton escorts President Kennedy to the reviewing stand at Fort Bragg to observe the firepower demonstration phase of his day.

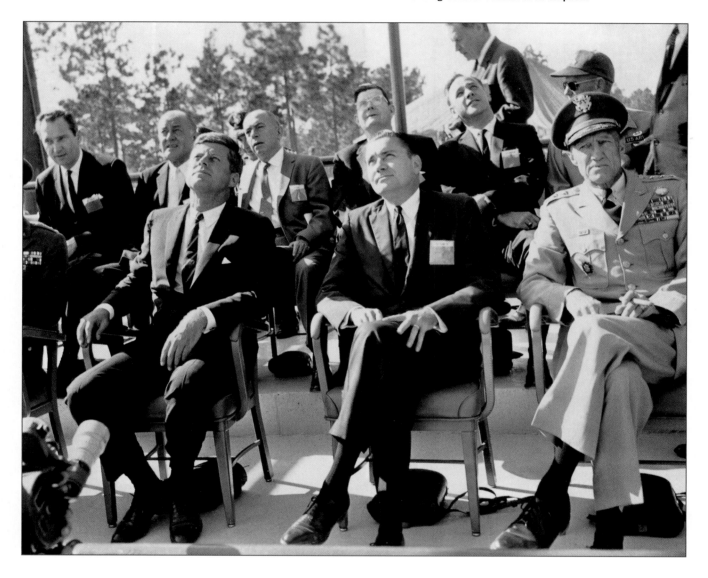

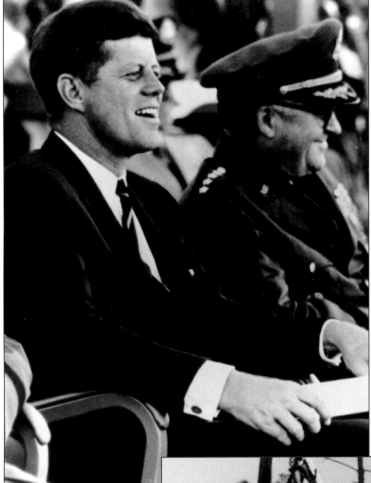

A hand-to-hand demonstration
elicited an appreciative response
from the president and General Decker.

The president's interest in the progress of army
training brought him to Fort Stewart on November 26, 1962. After the opening formalities at
Fort Stewart, Kennedy moved immediately to the
Confidence Course, accompanied by his hosts,
General Herbert B. Powell, Lt. Colonel Richard
A. Wise, and Captain Joseph A. Villa. As
Kennedy watched closely, soldiers from the First
Armored Division climbed thirty feet of rope
hand-over-hand, went down a ladder, crossed a
log platform, scaled a log barrier, then slid
down thirty feet of rope to the ground. It was the
sort of fitness test the president wanted to see.

The president stops his tour to talk briefly to Sgt. Lucien Brewer, Company B, Second Battalion, Fifty-second Infantry. At right is Brewer's commanding officer, Lt. Colonel Richard A. Wise.

The president, Secretary McNamara, and dozens of guests, including the shah of Iran, attended several days of naval exercises off the Atlantic coast in April 1962. Demonstrations included naval air operations off the carrier *Enterprise*, missile firings from the cruiser *Northampton*, and a marine amphibious assault on the beach near Onslow Beach, North Carolina. With the president on the reviewing stand to observe the amphibious assault portion of the Atlantic fleet exercises are, from left, front row: Vice President Lyndon Johnson; the shah of Iran; and General David Shoup.

Immediately behind the president are Admiral George W. Anderson, Jr., chief of naval operations, and Robert L. Dennison, commander in chief, Atlantic fleet.

The president is pleased to be made an honorary boatswain on the USS *Northampton.* CWO W2 Walter
D. Hogle presents the plaque to the president. It was just about this time that word reached the president that
U.S. Steel, which had locked horns with him in a bitter fight over steel prices, had backed down, giving him
a huge economic policy victory. Buoyed by this, the president relaxed and tried to enjoy the demonstration
of surface-to-air and air-to-air missiles from the deck. But the demonstration was a miserable failure, with
none of the vaunted Sidewinders, launched both from ships and from navy jets, striking the drone planes as
they passed overhead. The president expressed his displeasure to the undersecretary of the navy, Paul Fay.

The president and Secretary McNamara had a front-row seat for the carrier operations demonstration aboard the USS *Enterprise*, April 1962. The aircraft on the flight deck are A-5 Vigilantes, high-performance attack aircraft capable of delivering free-falling nuclear weapons. Except for the A-3 Skywarrior, the Vigilante was the heaviest aircraft in U.S. carrier service.

Kennedy and Captain Shepard talk to several members of a SEAL team (UDT-21) on the deck of the *Enterprise* after a water recovery demonstration. Kennedy admired the SEAL program and the men on the teams, finding them to be ideal examples of the kind of multitalented soldiers needed to counterpunch the Soviets in hot spots around the world.

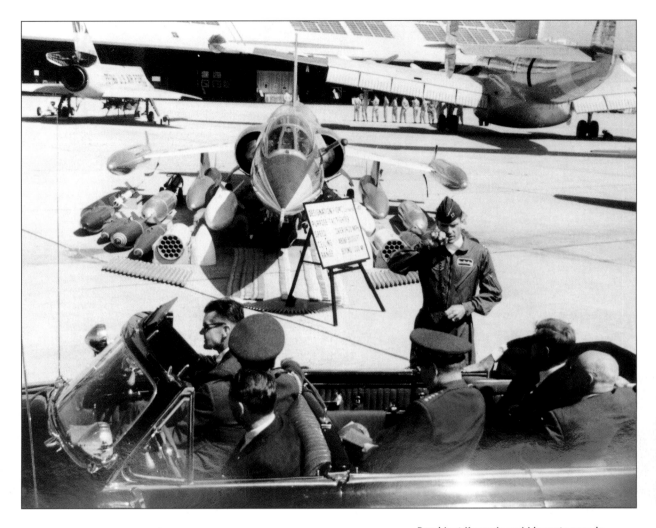

President Kennedy and his party pass in review of the jet and ordnance displays on the flight line en route to the firepower demonstration area. In the car with Kennedy are General Curtis LeMay and Eugene Zuckert, secretary of the air force.

The Thunderbirds, the air force's precision flying team, perform for the president and a large crowd of civilians.

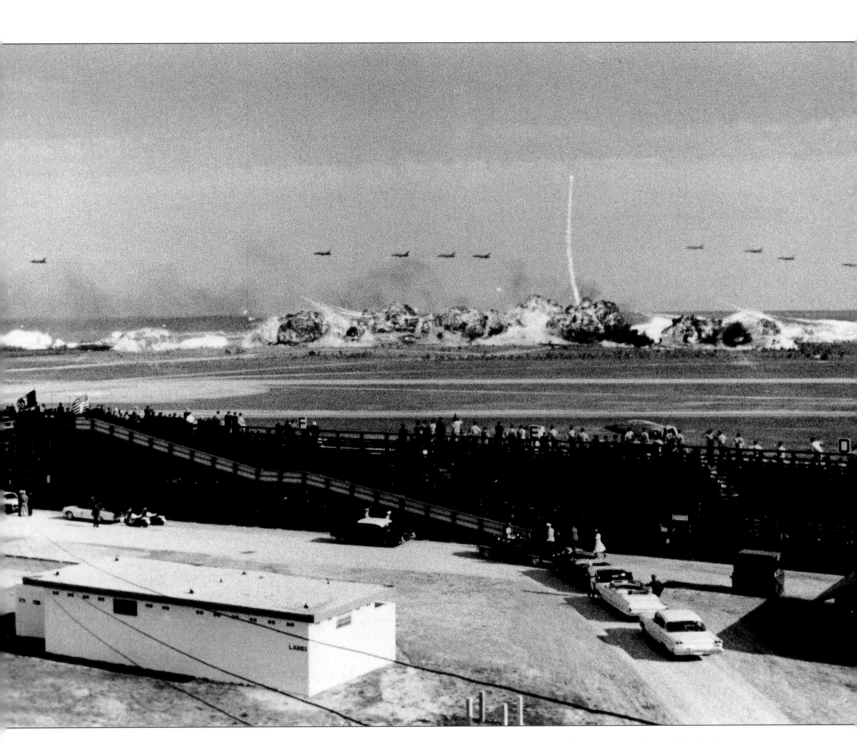

As America's military agenda filled up in the spring of 1962, President Kennedy flew to Florida for a demonstration of air force firepower at Eglin Air Force Base, on May 4. As he watched from a reviewing stand, with General LeMay at his side, Kennedy surveyed the inventory of America's aerial might. Here a flight of North American F-100s demonstrates a precision line of napalm for the president.

Inside Kennedy's circle it was not a secret that the president held several military men in low regard. General LeMay was on the top of the list. For Kennedy, LeMay embodied the things Kennedy disliked about a certain type of career military man—pretension, arrogance, blindness to subtlety, limited intellectual capacity. Part of Maxwell Taylor's job was to keep such men away from Kennedy.

Captain Ronald Everette presents a model of the Thunderbirds' F-100 to the President.

United States Army commanders gather for a group photograph with their commander in chief in the Rose Garden on November 30, 1961. Flanking President Kennedy are General George H. Decker, Chief of Staff, U.S. Army, and Secretary of the Army, Elvis J. Stahr, Jr. Included in the group behind them are: General Bruce C. Clarke, commander in chief, U.S. Army Reserve, Europe; General James F. Collins, commander in chief, U.S. Army, Pacific; General Guy S. Meloy, Jr., commanding general, Eighth Army; General Herbert B. Powell; Lt. General Andrew P. O'Meara, commander in chief, Caribbean Command; Lt. General Robert J. Wood, commanding general, Air Defense Command; Lt. General Edward J. O'Neill, commanding general, First Army; Lt. General Ridgely Gaither, commanding general, Second Army; Lt. General Thomas J. Trapnell; Lt. General Donald F. Booth, commanding general, Fourth Army; Lt. General Emerson L. Cummings, commanding general, Fifth Army; Lt. General John L. Ryan, Jr., commanding general, Sixth Army; Maj. General Theodore F. Bogart, commanding general, U.S. Army, Caribbean; Maj. General John H. Michaelis, commanding general, U.S. Army, Alaska; Maj. General Paul A. Gavan, commanding general, Military District of Washington.

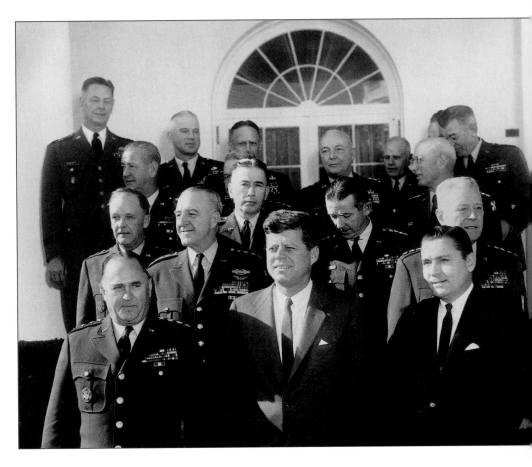

★ THE SPACE
★ PROGRAM
★

Three days after the flight of Glenn's *Friendship 7* came to a successful end near Bermuda, the president flew to Cape Canaveral to thank the colonel personally. It was a glorious moment for American technological prestige, and Glenn's wholesome, all-American personality just made it that much better. Glenn gives the president a full account of his three-orbit trip in *Friendship 7* as the two men look into the capsule window.

THE SPACE RACE

Very early in his presidential career I had the distinct impression that Kennedy was unhappy that the United States had not reacted more forcefully to the Soviet Sputnik program during the Eisenhower administration. We were in a highly competitive world situation with the Soviets, and their achievement was a tremendous coup for them and a humbling experience for us. It wounded Kennedy's sense of pride, but that was not the real inspiration for the growth of the National Aeronautics and Space Administration (NASA). What Kennedy saw in the Soviet space program was a threat to the balance of power. He said to me that if the Soviets could control space, it was going to be absolutely damaging to us and could easily lead to the development of Soviet offensive military capabilities that we would have no ability to counteract. His very firm conclusion was that the United States needed not just to match but to move ahead of the Soviet Union in space technology.

To Kennedy it was a defense and foreign policy issue more than a pure science issue, and he considered it one of the most important items on his national agenda. He told me he was talking to people right away about spearheading a new era of manned space flight. James Webb was soon appointed to head the National Aeronautics and Space Administration and carry out the president's plan.

Kennedy's advancement of the space program preceded his meeting with Khrushchev in Vienna in 1961, but at that meeting Kennedy floated the idea that perhaps the United States and the Soviet Union could work together in

At a special joint session of Congress on May 25, 1961, President Kennedy spoke stirringly of facing communism head-on. He asked the lawmakers for more money—$2 billion—to help meet the nation's military needs. In January he had requested more missiles and nuclear warheads. Now, four months later, he wanted more helicopters, more troops, more artillery, more vehicles—more of everything. The Congress cheered its OK. He also announced he was going to meet with Khrushchev in Vienna, a long-awaited and eagerly anticipated event that met with louder cheers. And, finally, Kennedy dropped this bombshell on the assembly: "I believe this nation should commit itself to achieving the goal, before the decade is out, of landing a man on the moon and returning him safely to earth." This was the part of the speech that made international headlines. But the other parts—the escalation of the cold war, the buildup of the military infrastructure, the implementation of Kennedy's new guerrilla warfare doctrine—had more far-reaching impact on the Kennedy presidency than all the orbits of the Mercury astronauts.

the exploration of space. It didn't exactly work out, although Khrushchev said at the time, "Why not?" We were not really up to speed with our space organization at that time. But thirty-four years later we are partners with Russia in space expeditions, Kennedy's idea in 1961.

KENNEDY ANNOUNCES HIS SPACE INITIATIVE

I will never forget his speech announcing the program to have our astronauts on the moon before the end of the decade. It was a public relations bonanza, because it galvanized and excited the public imagination like nothing I had ever seen before. It was an immediately popular idea. It was like a rivalry we had going with the Russians, almost a race, and all Americans were participating. Of course, the president did not get the satisfaction of seeing what his inspiration meant for us, but the rest of the world did.

It was 1969. I was in Greece staying at the home of the Greek defense minister, and we were watching Neil Armstrong's moon landing on television. I had a special radio, and I was hearing the broadcast on the Voice of America in English. I was very proud of the United States at that moment, and I thought back to Kennedy's role in the whole process. One of the things that bothered me at the time was Richard Nixon's integration into the accomplishment, because that created the impression that he had sent these men to the moon. Some people at that moment probably did not remember that it was John Kennedy who, in the early sixties, said we will send men to the moon before the end of the decade.

Re: NASA

The success of the Apollo program, having Armstrong on the moon, was a shock to the Soviets. They had made a huge effort to be the first on the moon. One of the cosmonauts, a Mr. Sevastianov, one of the first scientists in space, told me he was a member of the crew preparing for landing on the moon. And then suddenly it was stopped. The space race was of great importance to the Soviets. But it demanded so many resources from the Soviet economy that it was one of the reasons why the Soviet system collapsed.

The landing on the moon had no real scientific justification and no real military justification, but the development of the rocket program and the other things involved, computer systems and so on, was the right development path to take. On this Kennedy had the correct view.

—Marcus Wolf

Re: NASA

We analyzed Kennedy's position in the space race as being the same as his position in the arms race. It is one of the most important steps which had consequences all the way up to the demise of the Soviet Union. Kennedy pushed the effort forward in the space program, spending billions and billions of dollars, because in his lifetime the first man in space was a Russian, and it was a shock.

We were happy when Gagarin was in space. It showed the power of the Soviet Union, and we were sure it had military aspects. It wasn't said officially, but everybody knew that to have rockets that were able to take a space ship around the earth, it had a military possibility. So we thought that Soviet superiority in this area was very important in practical terms, but for our ideology, too.

—Marcus Wolf

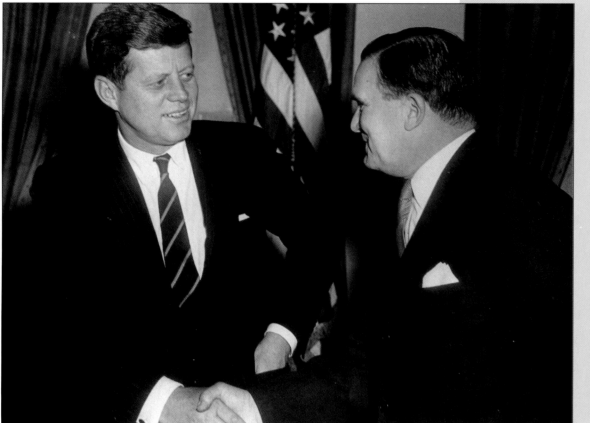

President Kennedy's appointment of James Webb to the post of director of the National Aeronautics and Space Administration came after a recommendation from Vice President Lyndon Johnson. Trained as a lawyer and experienced in both government and industry, Webb was the perfect man to guide the organization through the challenges of the Mercury program. He presided over an organization that soon gave the Kennedy administration some of its most popular accomplishments, and the president was always appreciative. But he was also concerned about NASA expenditures. One memo to the director of the Bureau of the Budget from Kennedy expressed concern about the new Manned Spacecraft Center in Houston: " . . . it seems to me that the cost is excessive for this center. . . . This program has so much public support that unless there is some restraint, there is a possibility of wasting some money."

All White House business came to a halt as astronaut Alan Shepard's suborbital flight lifted off on May 5, 1961. Vice President Lyndon Johnson, Arthur Schlesinger, Jr., Admiral Arleigh Burke, the president, and Mrs. Kennedy all crowded into Evelyn Lincoln's office to watch America's first attempt at manned rocket travel. Unlike the secret Soviet Union launches, the American program was shown live to millions. A failure would have been a huge loss of prestige for American science.

The development of the Saturn rocket program had begun during the Eisenhower administration, and when President Kennedy called for the United States to put a man on the moon, the Saturn's role became that of test vehicle for the Apollo program. Saturns were successfully launched from Cape Canaveral throughout 1962 and 1963.

THE MERCURY ASTRONAUTS

The individual triumphs of the Mercury astronauts were always cause for celebration at the White House. We had big parties for them. That's how I met John Glenn originally, and now I have known him for more than thirty years. I first met him at the White House after his earth orbit mission.

I have always seen John Kennedy's enthusiasm for NASA and its missions as one of the most important things that riveted the attention of the American public and got them in a positive frame of mind in a tense period in our history. The public began looking at Washington with a great deal more approval and respect through this space adventure. The president's poll results had always been good. He never went below a 50 percent approval rating, as more recent presidents have. A lot of that approval was from the reflected glow of the golden astronauts. They were heroes, and, for a few years at least, so was the man who was so instrumental in launching them.

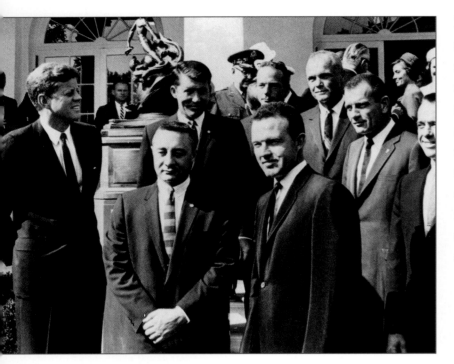

President Kennedy with the seven original Mercury astronauts. These men were chosen from a pool of about a hundred military pilots, who went through an elaborate screening process beginning in late 1958 and ending in April 1959. From the navy came Lt. Commander Walter Schirra, Lt. Commander Alan Shepard, and Lt. Scott Carpenter; from the air force, Capt. Deke Slayton, Capt. Gus Grissom, and Capt. Gordon Cooper; and from the marines, Lt. John Glenn. It was only natural for NASA to turn to the ready-made pool of military pilots for selecting their Mercury astronauts. With the benefit of years of research by the air force and navy in high-altitude performance and aerospace medicine, these men had experience in weightlessness, g-forces, and the other physical demands of rocket travel. Further, as military men they believed in duty and would be willing executors of any task the U.S. government asked of them.

The politics of space in 1962 required both money and the brightest minds in the nation. Kennedy and space program pioneer Dr. Wernher von Braun (left), in whom Kennedy invested both money and trust, are shown here on a September 1962 NASA inspection tour visiting the Huntsville-Redstone Army Airfield. They are accompanied by Vice President Lyndon Johnson.

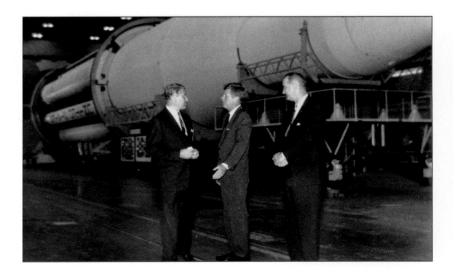

Alan Shepard (center) and John Glenn were the first and third American astronauts in space. President Kennedy enjoyed the positive publicity that came from these men and their accomplishments, but it hadn't always been his dream to send men to the stars. In fact, he was close to dismantling NASA when the Soviet Sputnik program and the flight of Yuri Gagarin captivated the worldwide press in April 1961. Kennedy could not have missed the political and psychological benefits of success in space, however, and he changed his mind. He wanted to know if the United States could really do the things he wanted done, such as to put a man on the moon, and asked German-born rocket scientist Wernher von Braun, who replied affirmatively. The cheers that resounded not only in Congress but around the world when Kennedy announced the Apollo program told the president that he had made the right decision.

President Kennedy had spoken to Khrushchev several times about the possibility of cooperative space ventures. He committed his thoughts to writing in this memo.

March 7, 1962
His Excellency
Nikita S. Khrushchev
Chairman of the Council of Ministers of the Union
of Soviet Socialist Republics, Moscow

. . . We are prepared now to discuss broader cooperation in the still more challenging projects which must be undertaken in the exploration of outer space. The tasks are so challenging, the costs so great, and the risks to the brave men who engage in space exploration so grave, that we must in all good conscience try every possibility of sharing these tasks and costs and of minimizing these risks. Leaders of the United States space program have developed detailed plans for an orderly sequence of manned and unmanned flights for exploration of space and the planets. . . . It may be possible to start planning together now. For example, we might cooperate in unmanned exploration of the lunar surface, or we might commence now the mutual definition of steps to be taken in sequence for an exhaustive scientific investigation of the planets Mars or Venus, including consideration of the possible utility of manned flight in such programs . . .

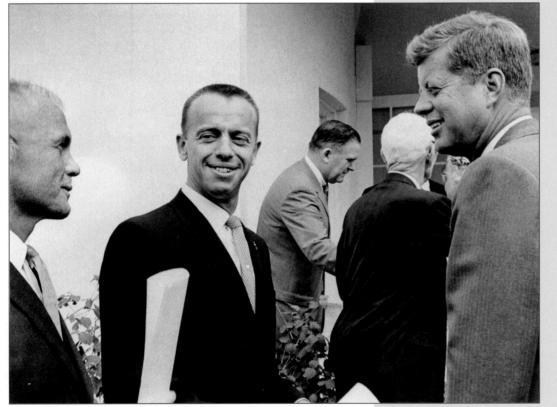

NASA training for its Mercury astronauts was so thorough that it included a jungle survival course. Here in June 1963 the astronauts try their hand at eating wild pork cooked over an open fire. Wally Schirra takes a piece from a cooking stick.

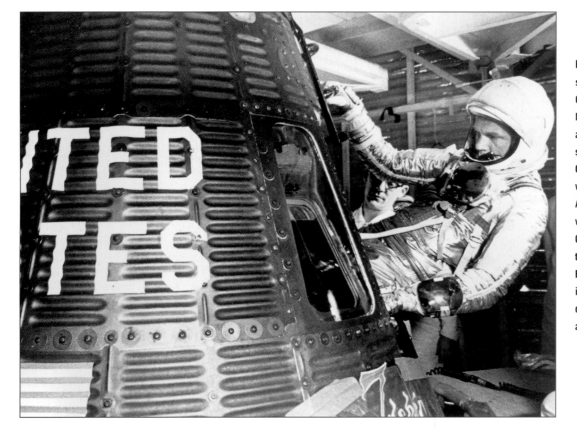

February 20, 1962. NASA had sent Alan Shepard and Gus Grissom on successful suborbital flights but had not been able to match the earth orbit success of the Soviets. John Glenn's flight on *Friendship 7* was the equalizer. All of America and the world watched on live television as Glenn circled the earth three times and landed safely near Bermuda. Here Glenn climbs into his Mercury capsule during prelaunch preparations at Cape Canaveral, Florida.

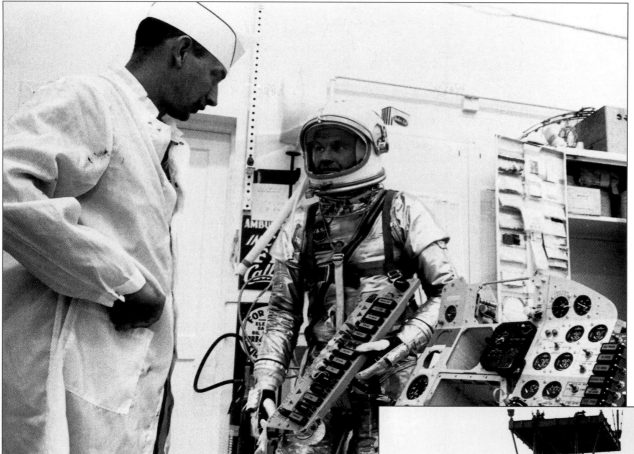

The race to the moon with the Russians created an environment of urgency within NASA, but the stakes were too high and the expectations were too great to speed into failure. NASA engineers thoroughly collected data on every imaginable aspect of biology, human performance, mechanics, and equipment soundness prior to actual launch. Engineers at the Republic Aviation labs conduct a moon surface adaptability test on the space suit Gordon Cooper is wearing.

The Apollo command module undergoes test landings in water, May 1963.

A five-day swing through the western states in June 1963 included stops at various military bases, including the White Sands Missile Range in New Mexico on June 5, 1963. Operation MEWS was under way as the president, hosted by Maj. General John F. Thorlin, commanding general of WSMR, watches a Sergeant ballistic missile being fired in the distance.

The president follows with binoculars the flight of a missile fired from Launch Site II at White Sands.

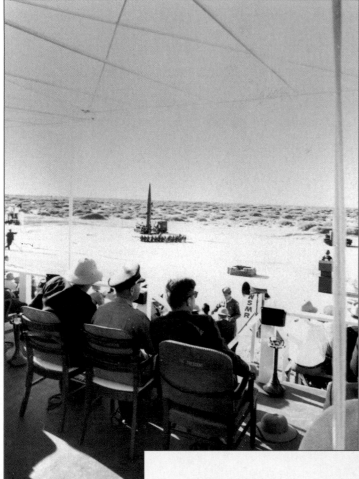

President Kennedy, Vice President Johnson, and General Thorlin are briefed by WSMR personnel about the Pershing missile, which stands on its launch platform in the background.

Sergeant Harmon Swits of the Third Missile Battalion of the Thirty-eighth Artillery presents the president with a scale model of a Sergeant ballistic missile.

On June 6, 1963, President Kennedy flew via helicopter to the flight deck of the USS *Kitty Hawk,* where he and his guests observed the naval demonstrations of Task Force Ten. This was another stop on a five-day western swing that had taken the President to NORAD in Colorado, White Sands Missile Range in New Mexico, and now to the Pacific Ocean off San Diego. The president and his entourage stayed overnight on the *Kitty Hawk.*

The flight deck crews aboard aircraft carriers are the men who make things go.
President Kennedy thanks the men of the *Kitty Hawk* for their work.

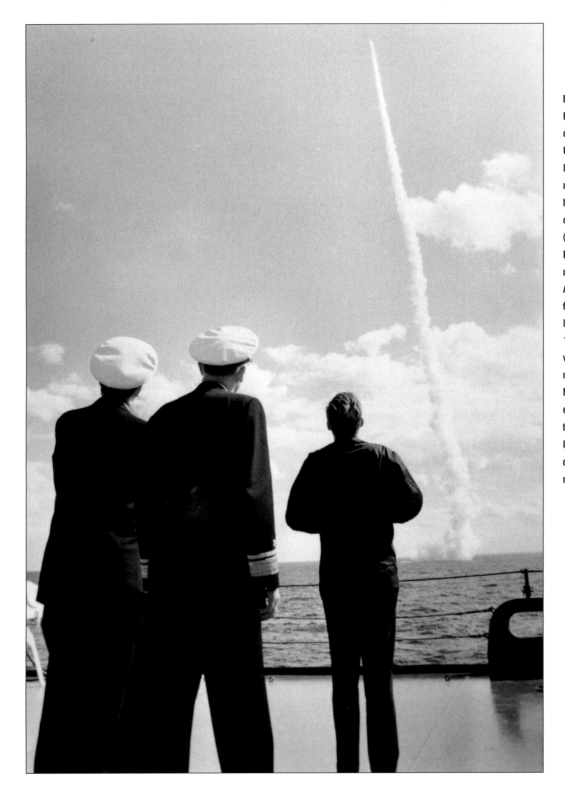

From the deck of the *Observation Island* President Kennedy got a close-up view of the launch of a Polaris missile. The U.S. Navy was the world innovator and leader in this type of shipborne strategic nuclear weapon and the Polaris was the best known of this class of weapons, called Sea-Launched Ballistic Missiles (SLBMs). It was hoped early on that the Polaris would fly a minimum of 2,500 nautical miles, but the first version, the A-1, did not achieve this distance when first launched in 1960. The A-2 version, launched later the same year, flew 1,500 miles. It was not until the A-3 version in the mid-1960s that the 2,500 nautical mile goal was achieved. Nonetheless, the Polaris versions of the early 1960s were operationally superior to the Russian SLBMs Sark and Serb, launched from the Golf class of Soviet diesel-powered submarines, which had a range of 700 nautical miles.

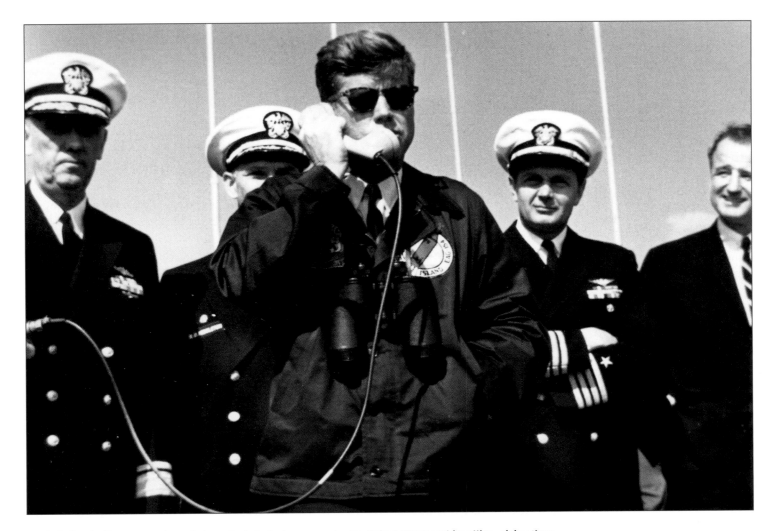

The Polaris missile was an extremely important strategic weapon for the United States and its allies, giving them a covert nuclear platform for which the Soviets had no good countermeasure. As both American and Soviet historians have observed, President Kennedy both abhorred the thought of a nuclear exchange and championed the development of such weapons as the Polaris, fearing that anything less than nuclear parity with the Soviets was an invitation for them to launch a preemptive strike. President Eisenhower had personally told Kennedy that the Polaris missile was America's "invulnerable" key to nuclear victory. By the end of 1961, though, Kennedy was aware that the nuclear weapons race was not a race at all—the United States had clear superiority. But nuclear strength was a political and diplomatic priority, and the Polaris was a powerful symbol of U.S. military might. Navy brass surrounds the president as he observes air-sea flight operations from the USS *Observation Island*. With the president are Rear Admiral Ignatius Galatin, Captain Shepard, and Rear Admiral Vernon L. Lowrence. The president was given this ship's jacket from the officers of the *Observation Island*. A phone link was established so the president could initiate the Polaris firing sequence from the *Observation Island*. Joining the navy contingent is Senator George Smathers of Florida (far right).

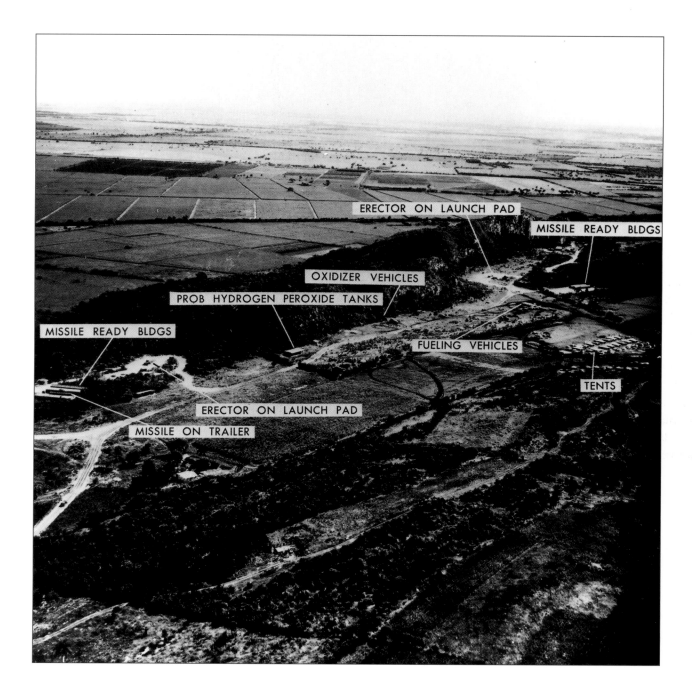

ERECTOR ON LAUNCH PAD

MISSILE READY BLDGS

OXIDIZER VEHICLES

PROB HYDROGEN PEROXIDE TANKS

MISSILE READY BLDGS

FUELING VEHICLES

TENTS

ERECTOR ON LAUNCH PAD

MISSILE ON TRAILER

★ THE CUBAN
★ MISSILE CRISIS
★

A medium-range ballistic missile (MRBM) field launch site in the San Cristobal area of Cuba, October 14, 1962. This photograph, provided by high-flying reconnaissance U-2s of the air force, was among the pictures submitted to President Kennedy on the morning of October 15 by McGeorge Bundy that established beyond a doubt that the Soviets and Cubans were creating a missile launch capability in Cuba. The very first U-2 shots had been taken on August 29 and shown to the president on August 31.

On October 16, 1962, a Tuesday, I walked into the Oval Office for a routine briefing and was met by a preoccupied president who told me that Andrei Gromyko was coming to see him on Thursday, and that he expected a lot of traffic through his office that week—Rusk, McNamara, Stevenson, the chiefs of staff. "If the press tries to read something significant into it," he said, "you're to deny that anything special is going on." When had I heard that before? It was all the signal I needed to know that something big was happening.

An American reconnaissance plane had recently flown over Cuba taking pictures and had discovered that there were sites on the island where Cubans and Soviet technicians were starting to construct launch platforms for medium-range ballistic missiles. The discovery was not entirely accidental. Reconnaissance missions over Cuba had been an ongoing military project, personally ordered by Kennedy, because analysts suspected that the Soviets might be up to something in Cuba. This time, as the plane flew over, it saw the work in progress. The pictures were immediately brought to Kennedy.

Tuesday afternoon I saw a lot of cars coming into the side entrance of the White House; there was a meeting scheduled, but I didn't know what it was about. Wednesday, we flew to Connecticut to support Abraham Ribicoff in his midterm election campaign. We came back to Washington by midnight. Over the next thirty-six hours I kept a log of people who met with the president. It included Johnson, Rusk, McNamara, Bobby Kennedy, John A. McCone of the CIA, General Taylor (now chairman of the Joint Chiefs), Bundy, Sorensen, O'Donnell, and a huge number of high-ranking staffers for state and defense.

That Friday, the nineteenth, we left on a political swing through the Midwest and the West Coast. Despite the impending crisis, Kennedy thought it important to bolster and increase the Democratic congressional majority in the midterm elections. While we were on these trips, the gatherings of staffers and advisers (a group known as EXCOM) continued to debate what action to take in response to the Soviet presence in Cuba. There were all kinds of disputes on policy and contingencies. The generals wanted to conduct immediate bombings in the area of Cuba where the launch sites were being built. The group said no. Adlai Stevenson's view was exactly the opposite. He said, "What the hell difference does it make? This is not going to be a real threat." And then there were those with views in the middle. This time the president was seeking advice from everyone and questioning everything rather than relying on the advice of a small group of strangers, as he had done on the Bay of Pigs.

When we got to Chicago on the afternoon of the nineteenth, I suddenly started getting calls from members of the press. They said, in essence, "We're seeing troops being gathered in Florida and we're seeing some ships in Virginia, with troops going aboard."

I said, "I don't know anything about it. Let me check." I tried to reach the president, but he was deep in session. I was concerned. I got hold of Ken O'Donnell. O'Donnell said to me, "Disappear tonight. Go somewhere and have dinner. Just don't have dinner with the press." I had a dinner party planned with Bill Mauldin, Irv Kupcinet, and other great friends of mine in the press. I couldn't cancel. That evening nobody probed me too hard, but Kupcinet did ask me how my supply of Cuban cigars was holding out.

GETTING THE REAL STORY

On the twentieth of October, still in Chicago, I got a call from Kennedy around ten minutes to eight. He said, "Come up to my room." When I got there he was in his bathrobe, and he had a yellow pad in his hand. He wrote some notes on it and showed it to me. It said: "I've got a bad cold; 99.2 degrees temperature. The doctor says I have to go back to Washington for medical care." He said, "Please hold a press conference and announce that we are canceling the rest of the trip."

I went down and held a press conference, saying to the reporters, "This trip is over. Get your bags, go to the airport, and get on the plane, because we're going back to Washington."

Re: Cuban Missile Crisis

Khrushchev compared the American position in West Berlin, and to an extent America's position in Turkey near the Soviet border, with his own position in Cuba. Why could American missiles be near our border in Turkey, and we could not be in Cuba with ours? Also, it was declared and known that Cuban emigrés were in Florida preparing a new attempt to take back the first socialist country on the American continent.

The president (back to camera) has an impromptu meeting with EXCOM members on the missile crisis. From left are McGeorge Bundy, Secretary of the Navy Paul Nitze, General Maxwell Taylor, and Robert McNamara.

We in the GDR did not have a feeling of the great danger which really existed in October 1962. It was only later that we learned from Soviet colleagues that it was a question of hours and minutes before the line between the cold and hot war would be crossed. I was told later that the Politburo's response to Kennedy's ultimatum to recall the Soviet ships came so near to the deadline that Khrushchev decided to be sure his message got to Kennedy in time by having the message sent by radio before the diplomatic pouch could arrive in Washington.

Even so, it was a Soviet adventure. It was not well analyzed by Soviet advisers; or perhaps Khrushchev's advisers told him to be careful, and he did not listen to them.

—Marcus Wolf

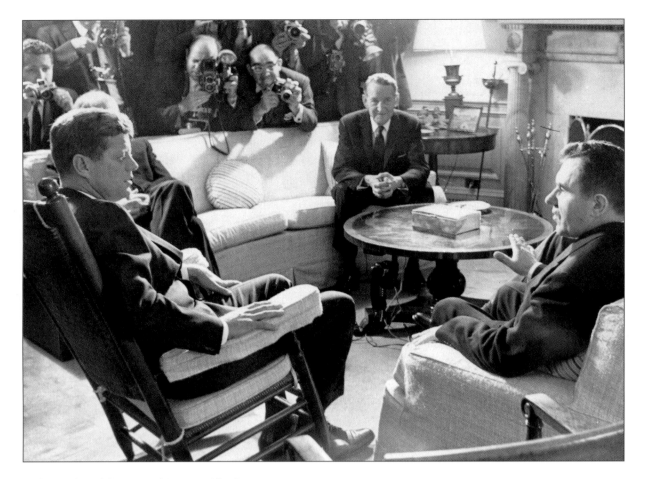

Soviet Foreign Minister Andrei Gromyko (right), former ambassador to Russia Llewellyn Thompson, and President Kennedy allowed photographers to enter the Oval Office for a photo opportunity after the October 18 talk. At this meeting, which Gromyko had requested, the talk was mostly about Berlin, but Kennedy suspected that Gromyko's real agenda was to find out how much he knew about the Cuban missiles. When the discussion turned briefly to weapons in Cuba, Gromyko assured the president that the Soviets would do nothing to upset East-West relations with the American elections so near. And besides, he smiled, the conventional weapons they were sending to Cuba were for defensive purposes only. The latest U-2 photographs had come in just hours earlier and were sitting in the president's desk drawer. It must have been tempting for Kennedy to pull them out and confront Gromyko, but the president did not tip his hand. He had not decided on a course of action and did not want the Soviets to plan for any contingencies. Later that evening, Kennedy told colleagues that Gromyko had lied to him, a fact that solidified Kennedy's already low opinion of the foreign minister.

I didn't go on the press plane. I went with Kennedy. About halfway through the trip, I decided I'd have to talk with the president, so I went into his special office on Air Force One while he was alone. I said, "Mr. President, you don't have a cold. Something strange is happening." He said, "The minute you arrive back in Washington you're going to find out what it is. And when you do, grab your balls."

When we got to Washington, I met with McGeorge Bundy and was fully briefed. Bundy told me we were on the brink of nuclear war. The medium-range ballistic missiles (MRBMs) in Cuba were not yet operational but would be in a few days. A naval blockade was being considered to force their removal. No one knew what Khrushchev's reaction would be, but it could be war.

In all of the crises with the Soviet Union, President Kennedy was smart enough to know not to back Khrushchev into a corner from which he would have no way out except by the use of nuclear weapons. He always wanted the Soviet premier to have a way out. A blockade of Cuba, rather than direct military action, would give Khrushchev that way out, and since it would take sev-

eral days to implement, it would also give everyone time to perhaps negotiate a settlement. The blockade idea was Bobby Kennedy's. Other choices included an invasion of Cuba by U.S. forces; a preemptive airstrike on the missile sites; taking our case to the U.N.; or secret negotiations with Khrushchev. The Soviets/Cubans had some cards to play, too. As a response they could invade West Germany; strike our missile bases in Turkey; attack Guantanamo; or threaten to execute all of the prisoners still in Cuban jails since the Bay of Pigs. In the meantime, new aerial photography from U-2 spy planes showed that Russian technicians were finishing work on several sites and were beginning work on new ones.

THE PRESIDENT'S PLAN OF ACTION

The near-constant meetings in the Situation Rooms of high-level advisers and military personnel could not have escaped notice by the Washington bureaucracy or the press. My phone was ringing off the hook. The press, counting the planes, ships, and troops heading for the Caribbean, requested confirmation of their speculations. I could only respond with, "No comment." To cool them down, though, I wanted the president to follow his normal routine, and when Sunday came, that meant he had to go to Mass. I went to his office to urge him to go. "Don't worry," he said, "I'm going." And he added, "Aren't you glad you didn't know all this before you had to?"

The meeting convened that Sunday morning felt like the real starting point of the Cuban Missile Crisis. Momentum was carrying this group of men and their leader to a number of important decisions on that morning. First, we would not ask for an immediate summit with Khrushchev, fearing it might be construed as a sign of weakness. Second, we decided to call our action a "quarantine" instead of a "blockade." Kennedy thought our allies, whom he wanted unified behind us, would find it easier to support language that was softer than the military word "blockade" implied. Third, U.S. ambassadors and other ranking diplomats would be dispatched to consult with heads of state around the world, with photos in hand to verify our claims. Fourth, Adlai Stevenson would present our case in the U.N. Security Council. Fifth, we would make arrangements to carry the president's speech to the Cuban people through Spanish-language commercial stations on the East Coast and in Florida.

The president had specific instructions for me. I was to ask the networks for thirty minutes' air time at 7:00 P.M. the next evening, Monday, the twenty-second; then, to

A series of meetings was held at the White House to discuss the situation in Cuba and options for action on October 18, 1962. The photographic evidence of the construction of nuclear missile sites in Cuba was presented to the president. Later, the discussion turned to the military and diplomatic choices to be made. A briefing paper listed the available options and numbered them from roman numeral one through five.

Meeting participants included: President Kennedy, Robert Kennedy, General Maxwell Taylor, Robert McNamara, McGeorge Bundy, Llewellyn Thompson, Douglas Dillon, Dean Rusk, and others.

These meetings were tape recorded. The tapes were released for public use by the Kennedy Library on July 27, 1995. The overall quality is only fair; it is often impossible, due to shuffling of papers near the microphone and other room noise, to distinguish what is being said or who is speaking. Some voices, such as the president's, are identified and noted. The transcripts below are presented to provide historical perspective.

Secretary of Defense Robert McNamara: Mr. President, there is listed here a series of alternative plans ranging from numeral one—about fifty sorties directed solely against the known MRBMs, known as of last night—through numeral five, which covers alternative strafing plans. All of these plans are based on one very important assumption—that we would attack with conventional weapons against an enemy who is not equipped with operational nuclear weapons. If there is any possibility the enemy is equipped with operational nuclear weapons, I'm certain our plans would have to be changed.

Last evening we were discussing the relative merits of these forms of military action, assuming that some form of military action was required. It has been the view of the [Joint] chiefs, based on discussions of the last two days, and it is certainly my view, either roman numeral one and roman numeral two—very limited air strikes against very limited targets—would be quite inconclusive, very risky, and would almost certainly lead to further military action. Prior to which we would have paid an unnecessarily high price for the gains we achieved. And therefore the chiefs and I would certainly have recommended last night, and I would recommend more strongly today, that we not consider undertaking either roman numeral one or roman numeral two. In other words we consider nothing short of a full invasion as practical military action, and this only on the assumption that we're oper-

ating against a force that does not possess operational nuclear weapons.

. . . Last evening it was my personal belief that there were more targets than we knew of, and that it was probable that there were more targets than we *could* know of at the start of any one of these air strikes. The information of this morning, I think, simply demonstrates the validity of that conclusion of last evening. Secondly, when we're talking about roman numeral one, it's a very limited strike against MRBMs only, and it leaves in existence IL-28s with nuclear weapon–carrying capability, and a number of other aircraft with nuclear weapon–carrying capability, and aircraft with strike capability that could be exercised during our attack or immediately following our attack on the MRBMs, with great possible risk and loss to either Guantanamo and/or the eastern coast of the U.S. I'm not thinking in terms of tens of thousands, but I'm thinking in terms of sporadic attacks against our civilian population which would lead to losses. I think we would find it hard to justify in relation to the alternative courses open to us, and in relation to the very limited accomplishment of our limited number of strikes.

Kennedy: Let me ask you this, Bob, when we're talking about number three versus number five, the advantage of number three is that you hope to do it in a day, while number five would be seven or eight or nine days with all the consequences . . .

McNamara: That is correct.

Kennedy: If we did number three would we assume that by the end of the day their ability to use planes against us—after all, they don't have that much range so they'll have to come back to the field . . .

McNamara: You would assume by the end of the day their air force would be nearly destroyed. I say nearly because there could be a few stray weapons around.

Kennedy: They're not going to permit nuclear weapons to be used against the United States from Cuba unless they're going to be using them everyplace.

McNamara: I'm not sure they can stop it. This is why I emphasized the point I did. I don't believe the Soviets would authorize their use against the U.S., but they might, nonetheless, be used. And therefore I underline this assumption, that all these cases be based on the assumption

that there are no nuclear weapons there. If there's any possibility of that, I would strongly recommend these plans be modified substantially.

Let's go back one second. I evaded the question Secretary Rusk asked me, and I evaded it because I wanted this information first. The question he asked me was, How does the introduction of these weapons into Cuba change the military equation—the military position of the U.S. versus the USSR. Speaking strictly in military terms, or in terms of weapons, it doesn't change it at all, in my personal opinion. My personal views are not shared by the chiefs—they're not shared by many others in the department. However, I feel very strongly, Mr. President, and I think I could argue a case, a strong case from the Defense Department position, this doesn't really have any bearing on the issue, in my opinion, because it's not a military problem that we're facing. It's a political problem. It's a problem of holding the alliance together, it's a problem of properly conditioning Khrushchev to our future moves, the problem of dealing with our domestic public—all requires action that in my opinion the shape of military balance does not require.

Kennedy: If we give, say, this twenty-four-hour notice—getting in touch with Khrushchev before taking action with our allies—I would assume that they would move these mobile missiles into the woods, yes?

McNamara: Mr. President, I don't believe they're equipped to do that. I say that because if they were equipped to do that they would have been equipped to erect them more quickly. I think it's unlikely they would move them in twenty-four hours. If they were to move them in twenty-four hours I think we could keep enough deposits over the island during that period to have some idea where they'd moved, and have every reason to believe we'd know where they were.
. . . I didn't say they couldn't get them into intermediate range in twenty-four hours. But I don't believe that we would lose them with a twenty-four-hour discussion with Khrushchev.

Kennedy: Say we sent somebody to see him [Khrushchev] . . . how long would it be before Khrushchev's answer could get back to us?

Answer: Five or six hours, I'd guess.

The discussion turns to what ifs, trying to predict the Soviet reaction to a variety of options.

Voice: So far, we know there's no stated relationship that makes these Soviet missiles, or Soviet bases. . . . The attempts Castro made to ally himself with the Warsaw Pact or to join the Warsaw Pact or even to engage in a bilateral group with Moscow probably failed. . . . He sent Raul [Castro] and Che Guevara to Moscow a few months ago apparently for that purpose. Hence, if we were to take action with this present status, the Soviets could have some latitude. On the other hand, as a result of warning, or communication with them, they [could] declare these are their bases, then we would have a big-time problem, because it would be a problem of an action against a base of theirs, and this might mean a war of different forces.

Kennedy: The question is, really, whether Soviet reaction would be measured differently if they were presented with an accomplished fact . . . whether their reaction would be different than it would be if they were given a chance to pull 'em out. If we said to Khrushchev that you have to take action . . . you pull 'em out, we'll take ours out of Turkey . . . whether he would then send back, "If you take these out, we're going to take Berlin, or we're going to do something else . . ."

Voice: If you do this first strike, you're going to kill a lot of Russians. . . . On the other hand, if you do give them notice, the thing I would fear most is a threat to Turkey and Italy, to take action there.

Kennedy: What is your preference?

Voice: My preference is the blockade plan. . . . I think it is highly doubtful that the Russians would resist a blockade against military weapons, particularly offensive ones.

Voice: If they're prepared to say, "All right, if you do this and this, it's nuclear war," they would do that anyway. If we make a lot of threatening language and very big terms . . .

Kennedy: I think it's more likely he'll just grab Berlin.

Voice: I think that, or if we make the first strike, I think his answer would be, very probably, to take out one of our bases in Turkey. I think the whole purpose of this exercise is to build up to [garble] in which we try to negotiate out the bases. It struck me very much: If the Soviets know how to camouflage these things, or to hide them in the woods, why didn't they do it in the first place? They expected us to see them at some stage. The purpose was for preparation for negotiation.

The president spoke to the nation from the Oval Office on October 22, 1962, concerning the missiles in Cuba. One network provided coverage of such speeches and fed it to the other networks, and this night it was CBS's turn. TV crews began setting up the office at 5:45, just after the president's briefing to members of Congress. The president's desk was cleared off, canvas covered the carpet, and the furniture was removed to make room for the cameras, lights, and press chairs. The president entered the office at 6:40 P.M. The TV lights were adjusted, the president went into the cabinet room to go over his speech one more time, and then he returned. He sat down behind his desk at 6:59 and at precisely 7:00 P.M. delivered the most important words of his presidency.

Simultaneously, in the air over Florida, nearly two dozen air force jets turned in unison toward Cuba, in case the Soviet response was belligerent.

organize the press briefings that would follow the address; and finally, to brief key congressional leaders two hours before Kennedy went on the air.

I must say that once the plan of action was put in place, the president was, as usual, the most composed, confident man in Washington. He was in control of his own faculties, his judgment was measured and sure, and his composure gave a calming effect to an otherwise charged atmosphere. He was a commanding figure, amazingly balanced given that the armed forces of the United States were on full alert and gathering in south Florida. The president took the time to call former presidents Hoover, Truman, and Eisenhower to advise them of the crisis and his plans to deal with it. Even on Monday, on the day he might initiate a possible nuclear showdown with the Soviet Union, the president would not cancel a long-scheduled visit from Prime Minister Obote of Uganda. In surely the most courteous (under the circumstances) effort in modern diplomacy, Kennedy spent nearly an hour with Obote discussing American aid to African schools while the National Security Council and the cabinet awaited their final briefings. But throughout the day, and the agonizing days to come, the unforgettable sight of our president's courageous optimism and his smiling encouragement was as inspiring as any commander's exhortations in American history.

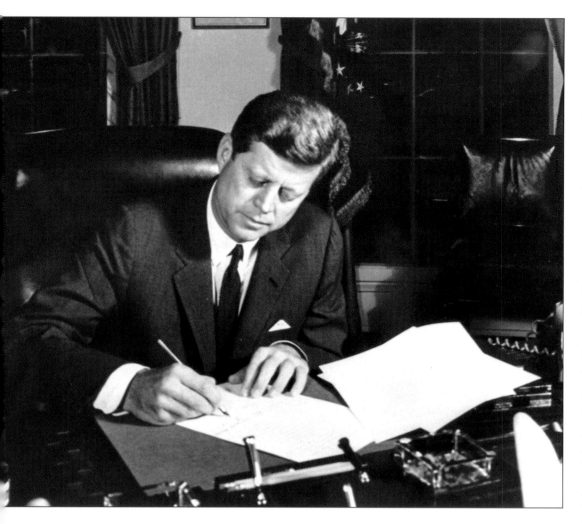

On October 23, President Kennedy signed the Proclamation of Interdiction of the Delivery of Offensive Weapons to Cuba, the legal instrument authorizing the naval blockade of Cuba, officially called a "quarantine." He had held off signing the document until the Organization of American States, the twenty-country alliance of Latin American states, voted on its own resolution calling for removal of the weapons in Cuba. Politically, OAS support was extremely important to the president. In a surprising show of pro–United States solidarity, the OAS voted unanimously to back the U.S. position and even to offer military assistance. Ambassador Stevenson wasted no time in announcing this historic vote in the emergency Security Council meeting the Soviets had called.

THE ADDRESS TO THE NATION

The atmosphere was electric when John Kennedy entered his office at 6:40 P.M., October 22. The Oval Office had been transformed to accommodate the television cameras and lights. At 6:50 he stepped aside into the nearby Cabinet Room to read his speech one final time. At 6:59 he was seated behind his desk, ready to deliver the most important words of his presidency. He wore no makeup, and his words to millions of rapt Americans, when the cameras finally came on, were all business.

His speech was brilliant in its clarity, directness, and tone. I suggest everyone reread it today—it is a model. He identified the provocative nature of the Soviet threat, explained what we were going to do about it, and made clear the consequences of Soviet action: "It shall be the policy of this nation to regard any nuclear missile launched from Cuba against any nation in the Western Hemisphere as an attack by the Soviet Union on the United States, requiring a full retaliatory response upon the Soviet Union." And finally this stirring ending: "The path we have chosen for the present is full of hazards, as all paths are, but it is the one most consistent with our character and courage as a nation and our commitments around the world. The cost of freedom is always high, but Americans have always paid it. And one path we shall never choose, and that is the path of surrender or submission."

The speech was over, the crisis that had been the secret property of a few dozen Americans in Washington now belonged to the world. And the world, like us, was frightened for its life.

This lower-altitude shot over San Cristobal on October 23 clearly shows the MRBM site in an advanced state of readiness. The clarity of this photograph and others gave worldwide credibility to the U.S. assertion that the Russians were establishing a forward missile base in North America. It also demonstrates the strategic advantage of high-resolution aerial reconnaissance in intelligence gathering. The traditional methods of getting information—through agents on the ground—had also indicated to U.S. authorities that the Soviets were building bases, but only the flyovers gave the CIA and military intelligence analysts a comprehensive understanding of the scope and speed of nuclear base construction.

THE SOVIET RESPONSE

The nature and scope of the military preparedness ordered by Kennedy was a secret to no one now, especially to the Soviets, who could easily see that Kennedy was prepared to take much more drastic steps if the quarantine didn't work. We had ten thousand troops ready to deploy, ninety warships, including eight aircraft carriers, on the water, Strategic Air Command planes ready to fly, and Polaris submarines in the area. But that didn't stop the Soviets from a provocative response to the president's speech. They ordered their own armed forces to alert status, as well as the forces of the Warsaw Treaty nations—East Germany, Czechoslovakia, Poland, Hungary, and Rumania. Khrushchev, in the first of many messages to Kennedy, characterized the quarantine as "piracy."

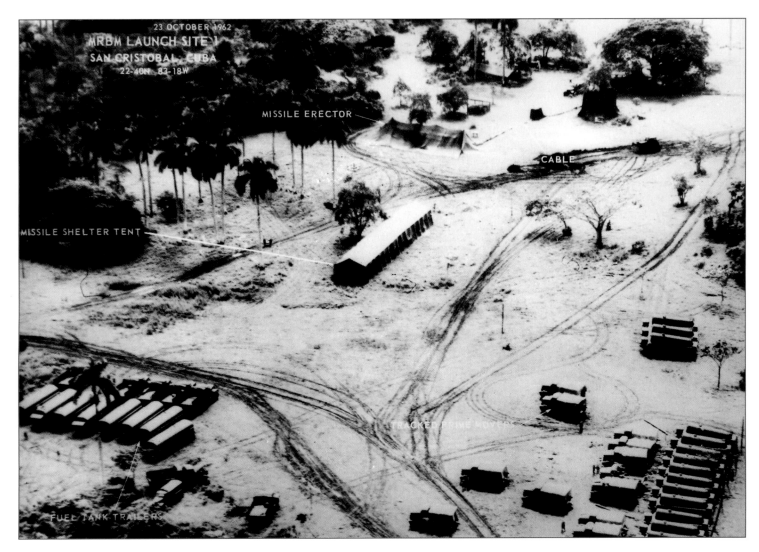

Early on, it appeared to the president that the Soviets and Cubans were mobilizing for a military response, both nuclear and conventional. The U-2s, which were so valuable both before and during the crisis, were showing round-the-clock work on the missile sites, along with the sudden appearance of Soviet IL-28 bombers on Cuban airstrips. And Russian submarines were reported to be accompanying the twenty-five ships heading for Cuba. In response, our commander in chief took appropriate action. He OK'd retaliatory airstrikes if one of our planes was attacked. He set out rules for interdiction on the high seas. He made military preparations for counterattacking a force that might move on West Berlin or attack the southeastern United States from the air. And he put twenty-four-hour tracking surveillance on the course and speed of the Soviet freighters moving toward Cuba. The lead ship, the *Bucharest*, would arrive at the U.S. blockade line on the morning of Thursday, October 25.

On Thursday, the president decided to let the *Bucharest* pass through the blockade without interference. Surveillance showed there could be no missiles on the ship, and there was a chance that its captain had not received any instructions from Moscow. On Friday the next ship, the *Marucla*, was boarded and searched—to no resistance. In an ironic coincidence, the U.S. destroyer that stopped the *Marucla* was the *Joseph P. Kennedy*, named for the president's older brother. But we had boarded a Soviet ship on the open sea, and we were not certain there would be no repercussions. We waited. I walked with the president in the Rose Garden and he said, "You know, if we don't succeed in bringing this crisis to an end, hundreds of millions of people are going to get killed."

The navy cordon around Cuba was set by October 24, and aerial reconnaissance put the arrival of the first Soviet ships to the barricade line on the morning of the twenty-fifth. Premier Khrushchev had told the president publicly and privately that his ships were going through. While the world held its breath, the first ship came into range of U.S. warships. It was an oil tanker, the *Bucharest*. The president personally gave the order to let it pass, even though some advisers wanted a symbolic detainment to demonstrate resolve.

THE TENSION MOUNTS

By Friday evening Khrushchev had communicated twice to Kennedy, once through his embassy and once in a personal letter, that he might remove the missiles and dismantle the sites in exchange for a pledge not to invade Cuba. This very hopeful development was shattered the next morning by the discovery that one of our U-2s was missing, presumed shot down by a Cuban surface-to-air missile. By Saturday evening a meeting had been scheduled for Sunday morning to decide whether an airstrike, which we had promised we would launch if one of our planes was shot down, would in fact be our response. In the absence of solid confirmation that the plane was lost, the president chose to hold off until the morning. To make matters even worse, Dean Rusk announced that a U-2 based in Alaska had that day strayed into Soviet airspace in Siberia. Soviet MIGs had been quickly deployed in pursuit, but they did not attack the U-2.

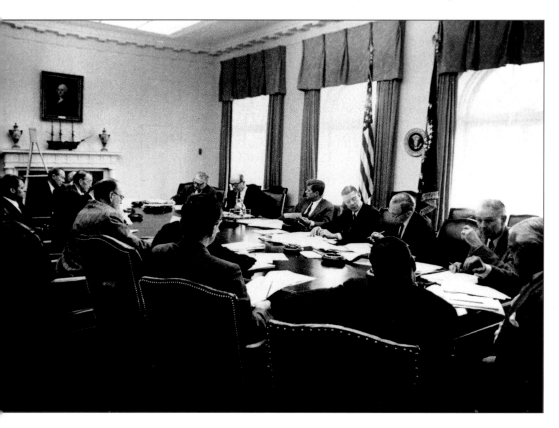

Earlier in the week this group of EXCOM members had planned to initiate the invasion of Cuba on October 29, 1962. Instead, on the same day, the group found itself reading the letter of capitulation from Chairman Khrushchev and composing a reply.

The military's estimate of the time needed for a successful invasion of Cuba was seven to ten days. This, to me, was becoming a plausible scenario—remote, but not impossible. An airstrike, at the very least, would have to be the U.S. response, if indeed our aircraft had been downed. The president, I believe, was prepared to issue such an order the next morning. Smarter military men than I—and that includes the president—were anticipating two or three moves ahead, and I am sure their analysis of the situation was that the Soviet Union could not bypass retaliation if hundreds or thousands of Soviet soldiers and technicians were killed in massive bombing raids or in an outright invasion. The president must have had the weight of the world on his shoulders that Saturday night, caught between the need to maintain our "courage" and honor our "commitments," as he had said in his speech, and his personal promise to himself that he would not lead the United States into nuclear war. He had said at the EXCOM meeting Saturday night, "That's the trouble with all that we're doing. Once we walk out of this room, people can start to get killed."

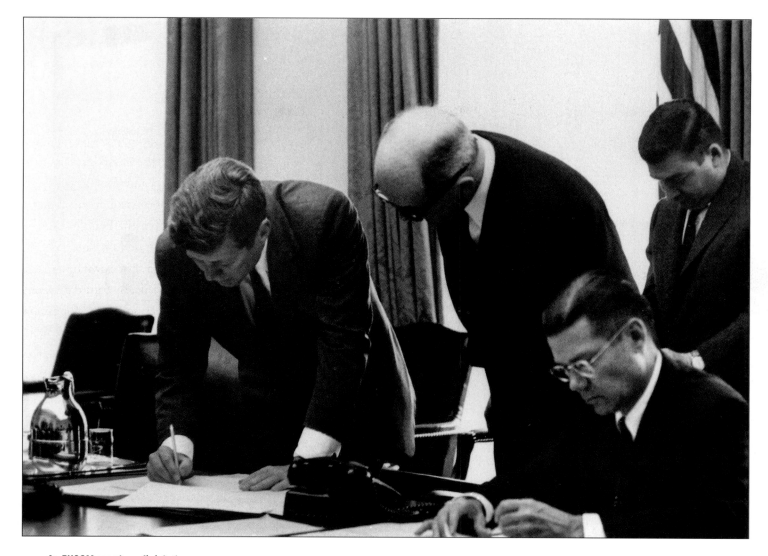

As EXCOM members finish the meeting on the twenty-ninth, President Kennedy, Dean Rusk, and Robert McNamara finalize the language of their official response to Khrushchev's morning communication. Pierre Salinger waits to release information to the press.

During these hectic days I was living in my office like everyone else, and that Saturday a curious thing happened. A messenger came by the office and handed me a sealed envelope. In it were the evacuation orders for my family in the event of a nuclear attack. The real dimensions of the crisis suddenly hit me in that moment, as it had to have hit everyone else on the staff who received a similar sealed envelope that day. In the days ahead I might have to phone my wife and tell her to drive out of Washington to a prearranged safe location out of the nuclear blast area, while the government literally went underground to conduct a nuclear response.

I was prepared to stay at the White House that Saturday night. The next move was Khrushchev's, and we did not know what he was going to do. I was prepared for anything. But the president did not want me to stay—in fact, he urged me to go home to see my wife and kids. The background thought was, you might not get another chance for a while.

President Kennedy and Robert McNamara stepped out of the EXCOM meeting of October 29 to discuss privately a detail of the missile-dismantling plan. The nearly unbearable tension of the previous week had broken, but no one believed the crisis was truly over yet. The hard work of monitoring the Soviet recall required much planning and vigilance.

How I got to sleep that night I'll never know, but early the next morning, as I was driving to the White House, I heard a newsflash on the radio that Khrushchev had sent a message to Kennedy saying he would withdraw the missiles and tear down the launch sites if the United States would agree not to invade Cuba. I could hardly believe it. None of us could have predicted such a fast capitulation. The morning's EXCOM meeting agenda changed. Instead of authorizing airstrikes, the president and his advisers were writing a reply to Khrushchev, applauding his "statesmanlike" course of action. I thought of a handwritten note I had slipped to Ken O'Donnell during the Saturday EXCOM meeting: "What is amazing is how the key presidential choices, made mostly in the dark, have worked out in a crisis situation."

It was true. The president had done everything right, again. His instincts, his judgment of Khrushchev, his assembly of advisers, his management of those advisers, and his personal courage had prevailed. Yet in this moment of triumph the president did not celebrate. His sense of balance—maybe even fairness—kept him from rubbing Khrushchev's nose in defeat. "This will wear off in about a week," he said. While congratulating and thanking everyone else, he himself took no personal credit for the successful outcome.

We learned something else that Sunday morning. Our U-2 *had* been shot down over Cuba, and the pilot, Major Rudolf Anderson, Jr., had been killed. What would the course of history have been if Khrushchev's message had not arrived Sunday morning and we were faced with responding to that news? Khrushchev himself would later point to the other U-2 incident over Siberia as the more serious flashpoint. That U-2, he said, "might have been taken for a nuclear bomber."

Re: Khrushchev/Cuban Missile Crisis

Khrushchev turned the ships around because he understood that this could be The War. His strategy was never to come to war. I think Kennedy made it clear by his strong position that this crisis would be the basis for war.

The military leaders of the Soviet Union underestimated the danger of atomic war. They believed until much later in the 1960s that they could win an atomic war. Khrushchev, to his credit, was very careful about playing with this weapon and the possibility that it could be used.

—Marcus Wolf

Soviet missiles began departing Cuba on November 5, 1962. Here the ship *Divinogorek* leaves with four missile transporters visible on the deck.

THE POSTMORTEM

A postmortem of the Cuban Missile Crisis occurred twenty-seven years later, in 1989. At the invitation of Mikhail Gorbachev, thirty alumni of the Cuban Missile Crisis convened in Moscow—ten Americans, ten Soviets, ten Cubans. I was one of the Americans. Over several days we compared notes on the historic events of October 1962. To a man, we were surprised by what we learned. For example:

• During the Cuban penetration of CIA files to get particulars on operation Mongoose, the plan OK'd by Kennedy to overthrow Castro, one particular purloined document gave the KGB the idea that October 1962 was the time set by the U.S. government for the removal of Castro. Khrushchev was convinced a U.S. invasion was coming in October; hence, the arrival of nuclear missiles.

• The strength of troops in Cuba, estimated at ten thousand, was in fact fifty thousand. And those troops were equipped with field-grade nuclear weapons. An invasion of Cuba would have had a tremendous cost in human life.

• Fidel Castro tried, early on, to convince Khrushchev to launch the missiles against the United States. In the end, when Kennedy and Khrushchev negotiated a settlement without involving Castro, he had flown into a rage that may still linger today. Castro, it seems, had figured he would get the Americans out of Guantanamo Bay, at the very least.

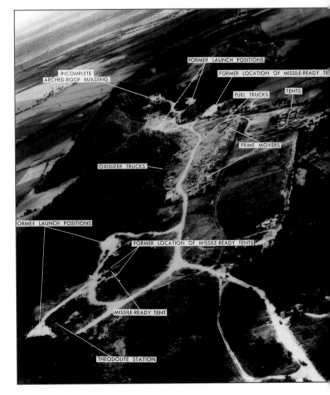

By November 1, Khrushchev had backed away from the brink, and dismantling work on the Cuban missile sites had already begun. Here at the Sagua La Grande MRBM site, the launch erectors have been completely removed from all four of the launch pads that had been constructed the previous month. Also removed were three launch-assist buildings and the launch pads, which were bulldozed over.

Re: Castro/Cuban Missile Crisis

Castro was very angry when Khrushchev backed out of Cuba. It was known that he was not happy having Soviet weapons on his territory in the first place. Later, after accepting the weapons, he was not informed before Khrushchev changed his position. When I was in Cuba in January 1965 I felt the disillusion among the Cuban leadership in the Soviet Union as a superpower.

Castro, like the other revolutionaries in Cuba, was a fighter. They are ready to fight to the death—*patria o muerte* is the well-known phrase. It is necessary to take it seriously. The biggest problem for Castro was the decision to stop the ships and send the missiles back to the Soviet Union *without his knowledge*. Many Americans do not understand how very proud the representatives of small countries can be. I think Castro is an intelligent man, and he understood the policy decision very well. But he had his own mind, and his own pride.

—Marcus Wolf

This walnut plaque with a sterling silver calendar of the month of October 1962 was a gift from the president and Mrs. Kennedy to key members of the administration's Cuban Missile Crisis team. The initials for both the president and Mrs. Kennedy are engraved at the top.

A New Era of Cooperation?

The private and secret correspondence between Kennedy and Khrushchev that I mentioned earlier continued in the months that followed the missile crisis. A "hot line" was installed so that faster communications—and faster understandings—could be effected. But the thing that thawed U.S.–Soviet relations more than anything was Kennedy's speech at American University in June of 1963. Khrushchev told me personally that that speech was what really convinced him not only that Kennedy was going in the right direction but that he was going to change the world. In it, Kennedy said, "We do not want a war. We do not now expect a war. This generation of Americans has already had enough—more than enough—of war and hate and oppression. We shall be prepared if others wish it. We shall be alert to try to stop it. But we shall also do our part to build a world of peace where the weak are safe and the strong are just. We are not helpless before that task or hopeless of its success. Confident and unafraid, we labor—not toward a strategy of annihilation but toward a strategy of peace."

The degree to which this message resonated with Khrushchev convinced me in 1963 that I would see the end of the cold war. Khrushchev was unstinting in his admiration and praise for the direction Kennedy was taking. He respected Kennedy for his handling of the Cuban Missile Crisis. We had come a long way since the talks in Vienna when Khrushchev thought he could intimidate the young, inexperienced president.

But soon the Kennedy promise was snuffed out by an assassin, and Khrushchev lasted not even another year until he was deposed. The cold war, without these two men who now seemed to be understanding each other, would last another twenty-five years.

Re: Cuba and the U.S.

I believe the economic blockade of Cuba by the U.S. was and is a mistake in policy, because the revolution under the leadership of Castro was not a Communist revolution. It was not influenced or led by Moscow, or by the Cuban Communists. It was an intellectual revolution, like Latin American revolutions of an earlier time. The most important politician in the past for Castro was not Lenin, but José Martí. If American policy had been to allow Cuba to go its own social and political way, things could be quite different. America's influence would have been so strong. The Soviet Union is so far away, and its ability to help in the life of Cuba is so limited, over time America would certainly have had the dominant influence.

—Marcus Wolf

After the Cuban Missile Crisis was over, the president wished to thank the men and women of the armed services who had gone on alert so quickly. A swing through various army, air force, and navy bases in late November gave him that opportunity. Here at Homestead Air Force Base on November 26, the president sits on the back of a Lincoln Continental convertible to get a better look at the assembled troops.

Kennedy wanted to speak personally to some of the pilots who flew the missile crisis missions. He got his chance at Homestead, where his entourage and the press crowded in to hear the conversation.

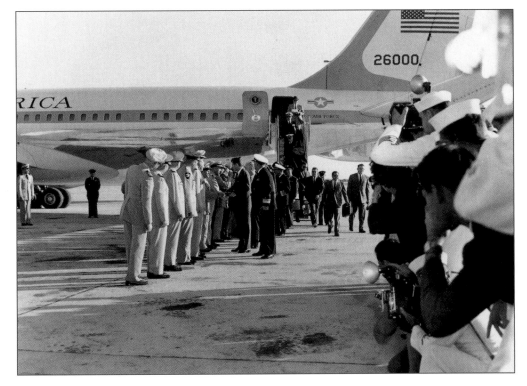

Another stop on the base tour of November 26 was the naval air station at Key West, Florida. Navy brass lined up to welcome the president's party.

The president's motor-cade at Boca Chica stopped so that Kennedy could speak to one of the missile crews that had set up a static display along the parade front.

The president's motorcade passes the parade front of jets.

The USS *Saufley* and its crew stand at attention as the president comes aboard as part of the Key West tour.

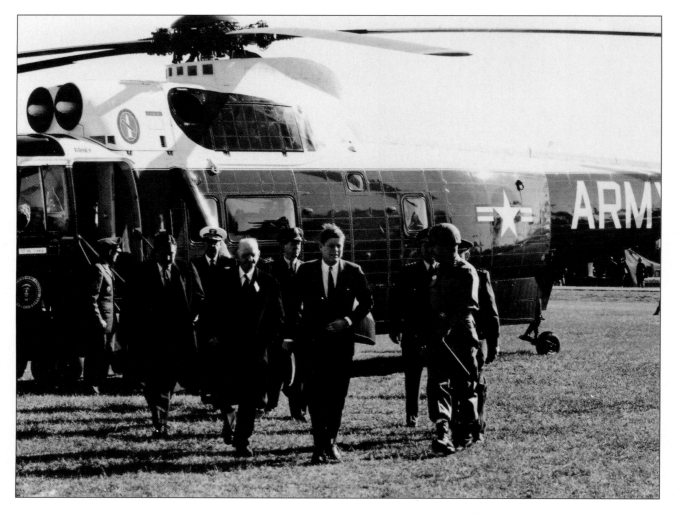

President Kennedy arrives via helicopter on November 26 to inspect units of the First Armored Division at Fort Stewart.

President Kennedy's motorcade passes in review of the massed armor of the First Armored Division. In his first presidential year, the president had ordered expansion of the army from fourteen divisions to sixteen, and he had specified that they be combat-ready, which set in motion a huge increase in the manufacture of conventional weapons—tanks, artillery, helicopters, and aircraft—in addition to nuclear missiles.

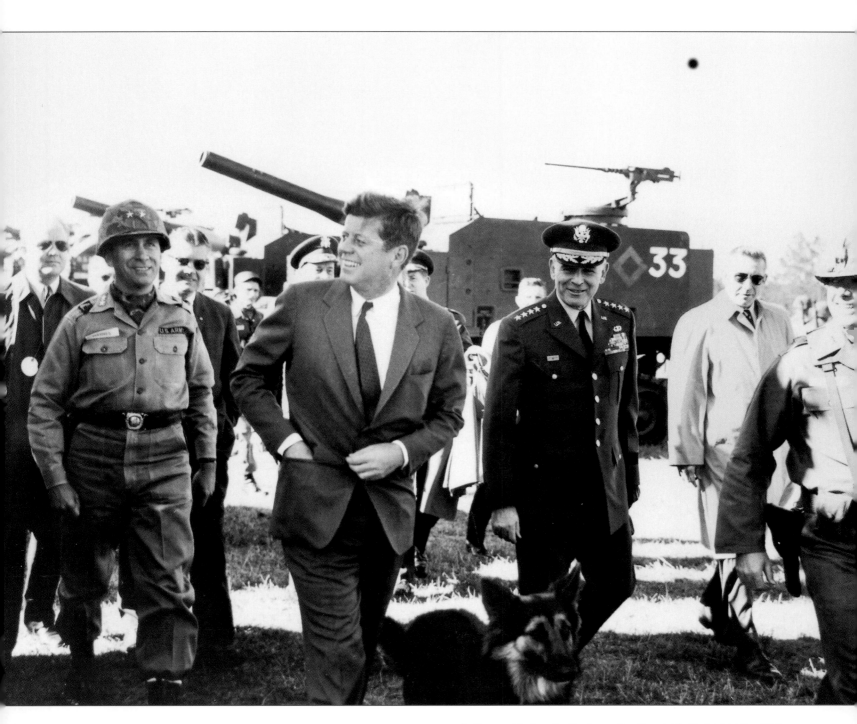

As the president walks the inspection line, he is flanked on the right by Maj. General Ralph Haines, Jr., commanding general of the First Armored Division, and on the left by General Maxwell Taylor. The dog in front of the president is the First Armored Division mascot.

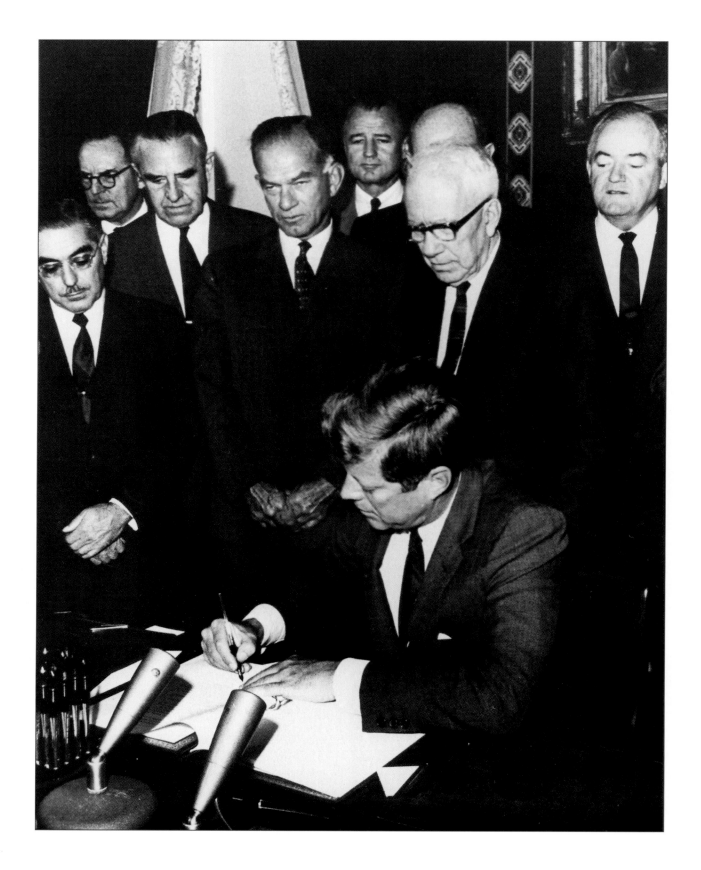

★ THE AMERICAN
★ UNIVERSITY SPEECH
★

President Kennedy signs the
Nuclear Test Ban Treaty,
October 7, 1963. He considered
this treaty to be the greatest
diplomatic accomplishment of
his presidency, hard-won over
many years of negotiation.

In a two-week period from June 10 to June 26, 1963, John F. Kennedy gave two of the greatest speeches of his presidency—the commencement address at American University, and the famous "Ich bin ein Berliner" speech in Berlin. This assessment of greatness comes from most of JFK's advisers, and from his widow, Jacqueline Kennedy Onassis, who adds her husband's inaugural speech to the others to make up the three best speeches of Kennedy's political life.

While much important business and many events remained for Kennedy between June and his assassination in November, the American University speech was a culmination of sorts for the president. It was perhaps the clearest expression of the president's 1963 world view, and surely a forecast of the foreign policy direction of the United States for the ensuing six years, presuming a second term. After nearly one thousand days of nuclear tension, of wins and losses all over the globe in the U.S.–Soviet competition for world domination, Kennedy had emerged from the crucible not with a battle-hardened military plan to do away with the Russian menace once and for all, but with a simple message of peace. In fact, Kennedy and his staff called this the "peace speech."

There had been considerable work done on this speech over the preceding months, and it showed. It was statesmanlike, altruistic, and practical all at once. It revealed Kennedy's personal, heartfelt desire for world peace as a moral mandate, and argued against war on rational grounds as well, invoking the need to spend money on badly needed social issues. As an exercise in diplomacy it worked, too, sounding the conciliatory note that Nikita Khrushchev had hinted he wanted to hear.

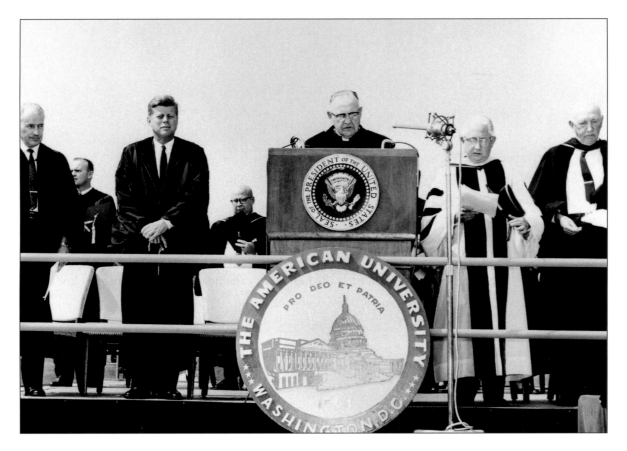

The president takes his place on the platform as commencement exercises begin. At this moment only he and Ted Sorensen know that the words he is about to say will have an impact not only on Khrushchev but on the Communist world.

Khrushchev, in fact, had let it be known through back channels that he would react affirmatively to Kennedy's recent call for a nuclear test ban if there were clear indications that Kennedy was earnestly moving toward rapprochement. This speech was the signal Khrushchev awaited. Two weeks later, Khrushchev endorsed the test ban idea in a speech in East Germany. Khrushchev told me personally that the speech was the one event which made him believe that peaceful coexistence with the United States was possible, and that old antagonisms could be forgotten. To Averell Harriman, Khrushchev said it was the greatest speech by an American president since Franklin Roosevelt. Not coincidentally, the speech was the first in years to be broadcast over Voice of America to Russia and middle Europe without jamming or interference. Soviet newspapers carried the entire text of the speech within days.

Kennedy was no fool; he knew the tensions of the cold war were not so shallow that they could be relieved by one speech. But this step was necessary. This was Kennedy's expression of maturity, of wisdom, of taking the long view. It was delivered plainly, without overemoting, as if the truth of the words needed no embellishment. Khrushchev must have felt the sincerity of the message, and must also have recognized in Kennedy a global consciousness that he had not seen two years earlier in Vienna.

If he had actually been in Washington on the day of the speech, Khrushchev might have said Kennedy looked tired. He was. He had just arrived in Washington an hour earlier after an overnight flight from Honolulu. The president had raced to the White House from the airport, changed clothes, and was driven to American University by 10:30 A.M. He was warmly received by university officials, and by the assembled graduates and their families. The speech delivered, the president returned to the White House, where plans were being finalized for the upcoming European trip.

The importance of the speech was not immediately recognized by the press. There was hardly any mention of it the next day in the newspapers. But insiders knew and appreciated the diplomatic effect it had.

Today, with the benefit of thirty years of hindsight, it is easy to see the beginning of a new statesmanship in this speech, perhaps the opening note of the symphony that would have been Kennedy's second term. An easing of tensions with the Soviet Union and a withdrawal of troops from Vietnam, which was clearly on Kennedy's mind, would have changed the nature of the 1960s profoundly, leading us to many tantalizing speculations about what America would be like today if Kennedy had not been killed in Dallas.

"There are few earthly things more beautiful than a university," wrote John Masefield, in his tribute to English universities—and his words are equally true today. He did not refer to spires and towers, to campus greens and ivied walls. He admired the splendid beauty of the university, he said, because it was "a place where those who hate ignorance may strive to know, where those who perceive truth may strive to make others see."

I have, therefore, chosen this time and this place to discuss a topic on which ignorance too often abounds and the truth is too rarely perceived—yet it is the most important topic on earth: world peace.

What kind of peace do I mean? What kind of peace do we seek? Not a Pax Americana enforced on the world by American weapons of war. Not the peace of the grave or the security of the slave. I am talking about genuine peace, the kind of peace that makes life on earth worth living, the kind that enables men and nations to grow and to hope and to build a better life for their children—not merely peace for Americans but peace for all men and women—not merely peace in our time but peace for all time.

I speak of peace because of the new face of war. Total war makes no sense in an age when great powers can maintain large and relatively invulnerable nuclear forces and refuse to surrender without resort to those forces. It makes no sense in an age when a single nuclear weapon contains almost ten times the explosive force delivered by all of the allied air forces in the Second World War. It makes no sense in an age when the deadly poisons produced by a nuclear exchange would be carried by wind and water and soil and seed to the far corners of the globe and to generations yet unborn.

Today the expenditure of billions of dollars every year on weapons acquired for the purpose of making sure we never need to use them is essential to keeping the peace. But surely the acquisition of such idle stockpiles—which can only destroy and never create—is not the only, much less the most efficient, means of assuring peace.

I speak of peace, therefore, as the necessary rational end of rational men. I realize that the pursuit of peace is not as dramatic as the pursuit of war—and frequently the words of the pursuer fall on deaf ears. But we have no more urgent task.

Some say that it is useless to speak of world peace or world law or world disarmament— and that it will be useless until the leaders of the Soviet Union adopt a more enlightened attitude. I hope they do. I believe we can help them do it. But I also believe that we must reexamine our own attitude—as individuals and as a nation—for our attitude is as essential as theirs. And every graduate of this school, every thoughtful citizen who despairs of war and wishes to bring peace, should begin by looking inward—by examining his own attitude toward the possibilities of peace, toward the Soviet Union, toward the course of the cold war and toward freedom and peace here at home.

First: Let us examine our attitude toward peace itself. Too many of us think it is impossible. Too many think it unreal. But that is a dangerous, defeatist belief. It leads to the conclusion that war is inevitable—that mankind is doomed—that we are gripped by forces we cannot control.

We need not accept that view. Our problems are man-made—therefore, they can be solved by man. And man can be as big as he wants. No problem of human destiny is beyond human beings. Man's reason and spirit have often solved the seemingly unsolvable—and we believe they can do it again.

I am not referring to the absolute, infinite concept of universal peace and goodwill of which some fantasies and fanatics dream. I do not deny the value of hopes and dreams,

but we merely invite discouragement and incredulity by making that our only and immediate goal.

Let us focus instead on a more practical, more attainable peace—based not on a sudden revolution in human nature but on a gradual evolution in human institutions—on a series of concrete actions and effective agreements which are in the interest of all concerned. There is no single, simple key to this peace—no grand or magic formula to be adopted by one or two powers. Genuine peace must be the product of many nations, the sum of many acts. It must be dynamic, not static, changing to meet the challenge of each new generation. For peace is a process—a way of solving problems.

With such a peace, there will still be quarrels and conflicting interests, as there are within families and nations. World peace, like community peace, does not require that each man love his neighbor—it requires only that they live together in mutual tolerance, submitting their disputes to a just and peaceful settlement. And history teaches us that enmities between nations, as between individuals, do not last forever. However fixed our likes and dislikes may seem, the tide of time and events will often bring surprising changes in the relations between nations and neighbors.

So let us persevere. Peace need not be impracticable, and war need not be inevitable. By defining our goal more clearly, by making it seem more manageable and less remote, we can help all peoples to see it, to draw hope from it, and to move irresistibly toward it.

Second: Let us reexamine our attitude toward the Soviet Union. It is discouraging to think that their leaders may actually believe what their propagandists write. It is discouraging to read a recent authoritative Soviet text on military strategy and find, on page after page, wholly baseless and incredible claims—such as the allegation that "American imperialist circles are preparing to unleash different types of wars . . . that there is a very real threat of a preventive war being unleashed by American imperialists against the Soviet Union . . . [and that] the political aims of the American imperialists are to enslave economically and politically the European and other capitalist countries . . .[and] to achieve world domination . . . by means of aggressive wars."

Truly, it was written long ago: "The wicked flee when no man pursueth." Yet it is sad to read these Soviet statements—to realize the extent of the gulf between us. But it is also a warning—a warning to the American people not to fall into the same trap as the Soviets, not to see only a distorted and desperate view of the other side, not to

see conflict as inevitable, accommodation as impossible, and communication as nothing more than an exchange of threats.

No government or social system is so evil that its people must be considered as lacking in virtue. As Americans, we find Communism profoundly repugnant as a negation of personal freedom and dignity. But we can still hail the Russian people for their many achievements—in science and space, in economic and industrial growth, in culture and in acts of courage.

Among the many traits the peoples of our two countries have in common, none is stronger than our mutual abhorrence of war. Almost unique among the major world powers, we have never been at war with each other. And no nation in the history of battle ever suffered more than the Soviet Union suffered in the course of the Second World War. At least twenty million lost their lives. Countless millions of homes and farms were burned or sacked. A third of the nation's territory, including nearly two thirds of its industrial base, was turned into a wasteland—a loss equivalent to the devastation of this country east of Chicago.

Today, should total war ever break out again—no matter how—our two countries would become the primary targets. It is an ironic but accurate fact that the two strongest powers are the two in the most danger of devastation. All we have built, all we have worked for, would be destroyed in the first twenty-four hours. And even in the cold war, which brings burdens and dangers to so many countries, including this nation's closest allies—our two countries bear the heaviest burdens. For we are both devoting massive sums of money to weapons that could be better devoted to combating ignorance, poverty, and disease. We are both caught up in a vicious and dangerous cycle in which suspicion on one side breeds suspicion on the other, and new weapons beget counterweapons.

In short, both the United States and its allies, and the Soviet Union and its allies, have a mutually deep interest in a just and genuine peace and in halting the arms race. Agreements to this end are in the interests of the Soviet Union as well as ours—and even the most hostile nations can be relied upon to accept and keep those treaty obligations, and only those treaty obligations, which are in their own interest.

So, let us not be blinded to our differences—but let us also direct attention to our common interests and to the means by which those differences can be resolved. And if we cannot end now our differences, at least we can help make the world safe for diversity. For, in the final analysis, our most basic common link is that we all inhabit this small planet. We all breathe the same air. We all cherish our children's future. And we are all mortal.

Third: Let us reexamine our attitude toward the cold war, remembering that we are not engaged in a debate, seeking to pile up debating points. We are not here distributing blame or pointing the finger of judgment. We must deal with the world as it is, and not as it might have been had the history of the last eighteen years been different.

We must, therefore, persevere in the search for peace in the hope that constructive changes within the Communist bloc might bring within reach solutions which now seem beyond us. We must conduct our affairs in such a way that it becomes in the Communists' interest to agree on a genuine peace. Above all, while defending our own vital interests, nuclear powers must avert those confrontations which bring an adversary to a choice of either a humiliating retreat or a nuclear war. To adopt that kind of course in the nuclear age would be evidence only of the bankruptcy of our policy—or of a collective death wish for the world.

To secure these ends, America's weapons are nonprovocative, carefully controlled, designed to deter, and capable of selective use. Our military forces are committed to peace and disciplined in self-restraint. Our diplomats are instructed to avoid unnecessary irritants and purely rhetorical hostility.

For we can seek a relaxation of tensions without relaxing our guard. And for our part we do not need to use threats to prove that we are resolute. We do not need to jam foreign broadcasts out of fear our faith will be eroded. We are unwilling to impose our system on any unwilling people—but we are willing and able to engage in peaceful competition with any people on earth.

Meanwhile, we seek to strengthen the United Nations, to help solve its financial problems, to make it a more effective instrument for peace, to develop it into a genuine world security system—a system capable of resolving disputes on the basis of law, of insuring the security of the large and the small, and of creating conditions under which arms can finally be abolished.

At the same time we seek to keep peace inside the non-Communist world, where many nations, all of them our friends, are divided over issues which weaken Western unity, which invite Communist intervention, or which threaten to erupt into war. Our efforts in West New Guinea, in the Congo, in the Middle East, and the Indian subcontinent have been persistent and patient despite criticism from both sides. We have also tried to set an example for others—by seeking to adjust small but significant differences with our own closest neighbors in Mexico and in Canada.

Speaking of other nations, I wish to make one point clear. We are bound to many nations by alliances. Those alliances exist because our concern and theirs substantially overlap. Our commitment to defend Western Europe and West Berlin, for example, stands undiminished because of the identity of our vital interests. The United States will make no deal with the Soviet Union at the expense of other nations and other peoples, not merely because they are our partners, but also because their interests and ours converge.

Our interests converge, however, not only in defending the frontiers of freedom but in pursuing the paths of peace. It is our hope—and the purpose of allied policies—to convince the Soviet Union that she, too, should let each nation choose its own future, so long as that choice does not interfere with the choices of others. The Communist drive to impose their political and economic system on others is the primary cause of world tension today. For there can be no doubt that, if all nations could refrain from interfering in the self-determination of others, the peace would be much more assured.

This will require a new effort to achieve world law—a new context for world discussions. It will require increased understanding between the Soviets and ourselves. And increased understanding will require increased contact and communication. One step in this direction is the proposed arrangement for a direct line between Moscow and Washington, to avoid on each side the dangerous delays, misunderstandings, and misreadings of the other's actions which might occur at a time of crisis.

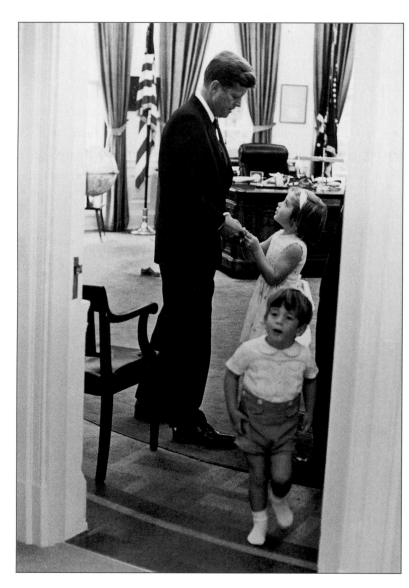

Even in the throes of crisis, President Kennedy retained his composure and his humanity. Oval Office meetings were often punctuated by visits from Caroline and John Jr. The president would take a moment to talk with them before resuming work.

We have also been talking in Geneva about other first-step measures of arms control, designed to limit the intensity of the arms race and to reduce the risks of accidental war. Our primary long-range interest in Geneva, however, is general and complete disarmament—designed to take place by stages, permitting parallel political developments to build the new institutions of peace which would take the place of arms. The pursuit of disarmament has been an effort of this government since the 1920s. It has been urgently sought by the past three administrations. And however dim the prospects may be today, we

intend to continue this effort—to continue it in order that all countries, including our own, can better grasp what the problems and possibilities of disarmament are.

The one major area of these negotiations where the end is in sight, yet where a fresh start is badly needed, is in a treaty to outlaw nuclear tests. The conclusion of such a treaty, so near and yet so far, would check the spiraling arms race in one of its most dangerous areas. It would place the nuclear powers in a position to deal more effectively with one of the greatest hazards which man faces in 1963, the further spread of nuclear arms. It would increase our security—it would decrease the prospects of war. Surely this goal is sufficiently important to require our steady pursuit, yielding neither to the temptation to give up the whole effort nor the temptation to give up our insistence on vital and responsible safeguards.

I am taking this opportunity, therefore, to announce two important decisions in this regard.

First: Chairman Khrushchev, Prime Minister Macmillan, and I have agreed that high-level discussions will shortly begin in Moscow looking toward early agreement on a comprehensive test ban treaty. Our hopes must be tempered with the caution of history—but with our hopes go the hopes of all mankind.

Second: To make clear our good faith and solemn convictions on the matter, I now declare that the United States does not propose to conduct nuclear tests in the atmosphere so long as other states do not do so. We will not be the first to resume. Such a declaration is no substitute for a formal binding treaty, but I hope it will help us achieve it.

Finally, my fellow Americans, let us examine our attitude toward peace and freedom here at home. The quality and spirit of our own society must justify and support our efforts abroad. We must show it in the dedication of our own lives—as many of you who are graduating today will have a unique opportunity to do, by serving without pay in the Peace Corps abroad or in the proposed National Service Corps here at home.

But wherever we are, we must all, in our daily lives, live up to the age-old faith that peace and freedom walk together. In too many of our cities today, the peace is not secure because freedom is incomplete.

It is the responsibility of the executive branch at all levels of government—local, state, and national—to provide and protect that freedom for all of our citizens by all means within their authority. It is the responsibility of the legislative branch at all levels, wher-

ever that authority is not now adequate, to make it adequate. And it is the responsibility of all citizens in all sections of this country to respect the rights of all others and to respect the law of the land.

All this is not unrelated to world peace. "When a man's ways please the Lord," the scriptures tell us, "he maketh even his enemies to be at peace with him." And is not peace, in the last analysis, basically a matter of human rights—the right to live out our lives without fear of devastation—the right to breathe air as nature provided it—the right of future generations to a healthy existence?

While we proceed to safeguard our national interests, let us also safeguard human interests. And the elimination of war and arms is clearly in the interest of both. No treaty, however much it may be to the advantage of all, however tightly it may be worded, can provide absolute security against the risks of deception and evasion. But it can—if it is sufficiently effective in its enforcement and if it is sufficiently in the interests of its signers—offer far more security and far fewer risks than an unabated, uncontrolled, unpredictable arms race.

The United States, as the world knows, will never start a war. We do not want a war. We do not now expect a war. This generation of Americans has already had enough—more than enough—of war and hate and oppression. We shall be prepared if others wish it. We shall be alert to try to stop it. But we shall also do our part to build a world of peace where the weak are safe and the strong are just. We are not helpless before that task or hopeless of its success. Confident and unafraid, we labor on—not toward a strategy of annihilation but toward a strategy of peace.

★ INDEX